Bernard Denvir

FAUVISM AND EXPRESSIONISM

BARRON'S

Woodbury, New York

First U.S. Edition 1978
Barron's Educational Series, Inc.

Text filmset by Keyspools Ltd, Golborne, Lancs
Litho origination by Paramount Litho Ltd, Wickford, Essex
Printed in Great Britain by Cox and Wyman Ltd,
London, Fakenham and Reading

Library of Congress Catalog Card No. 77-80181
International Standard Book No. 0-8120-0878-2

Printed in Great Britain

Expressionism is one of those words, like romanticism, which have a general and a specific meaning in their function of defining cultural phenomena. In its wider sense it is taken to describe works of art in which feeling is given greater prominence than thought; in which the artist uses his medium not to describe situations, but to express emotions, and allows it to be manipulated beyond currently accepted aesthetic conventions for that purpose. Further to enhance the effect on the spectator, the artist may choose a subject which in itself evokes strong feelings, usually of repulsion – death, anguish, torture, suffering. In a stylistic context, expressionism in painting often implies an emphasis on colour at the expense of line, largely because the effects of colour are less patient of a rational explanation than are the effects of line.

Expressionism in this sense is one of the constituent elements in the dialectic between thought and feeling which powers so much creative activity, and it is to be found, with varying degrees of intensity, in all periods and most cultures. The thirteenth-century Byzantine murals in the church of San Zan Degolà in Venice, Giotto's *The Mourning over Christ* in the Capella dell'Arena in Padua, Rembrandt's self-portraits, the etchings of Goya, and Delacroix's *Dante and Virgil in Hell*, are all symptomatic of its spirit.

In a more specific sense, however, Expressionism refers to the works of a large number of painters (among whom there were many varieties of style, and some of whom were absorbed into other movements),

who during the late nineteenth and early twentieth centuries translated the general principles of expressionism into a specific doctrine. In so doing they effected a transformation of the nature of art which made possible the traumatic revolution which it has experienced during the last three-quarters of a century. Expressionism in this sense involved ecstatic use of colour and emotive distortion of form, reducing dependence on objective reality, as recorded in terms of Renaissance perspective, to an absolute minimum, or dispensing with it entirely. Above all else, it emphasized the absolute validity of the personal vision, going beyond the Impressionists' accent on personal perception to project the artist's inner experiences – aggressive, mystical, anguished or lyrical – on to the spectator. Though this is to define Expressionism in terms of the visual arts, it was as powerful in music, literature and the cinema as it was in painting.

The revolt against rationalism, and the accompanying cultivation of the sensibilities, had been proceeding apace since the beginnings of the Romantic movement. But in the course of the nineteenth century it had received support from a variety of sources. The revolutionary mysticism of Kierkegaard, the existentialism of Heidegger, the tortured social preoccupations of Ibsen and Strindberg, the febrile anguish of Swinburne and Whitman, the aggressive Dionysian myths of Nietzsche, all created a climate of intellectual violence which intoxicated the young. The discoveries of Darwin reduced the status of man in the scale of life, and emphasized his relationship to other, more instinctual creatures. The theories of Marx suggested that he was the toy of history rather than its master. The researches of Freud, which made their impact felt most clearly in those countries where Expressionism flourished, suggested that our actions are not motivated by those processes of conscious thought on which we had placed such reliance.

Bergson stressed the subjective nature of perception, and the flow and flux between nature and the mind of man. In developing humanism, Western man had begun to alter his notions of humanity.

The romantic stereotype of the artist as an anguished creator, tormented into creativity by his finely attuned sensitivities, had become accepted by the 1870s, and it is not without significance that among those artists involved in Expressionism, at least six, Van Gogh, Munch, Ensor, Kirchner, Beckmann and Grosz, experienced psychotic as well as neurotic episodes. Nor was the situation helped by the temper of the times. Most of the Expressionists were young men when the Great War broke out, and old men when the horrors of Hitler's extermination camps were unveiled. Events provided them with as much anguish as they needed, and their involvement with the more macabre aspects of history is reflected in such coincidences as that the leading Expressionist magazine in Berlin was entitled *Der Sturm*, foreshadowing the Stormtroopers of a later decade.

There were recent precedents for the Expressionists' hunger for sensation. In the 1880s and 1890s the so-called Decadents and the Symbolists had explored sex, drugs, religion, mysticism, magic and alcohol as paths to creativity, and in so doing had helped to cast the artist in the role of archetypal rebel against society and the establishment. The Expressionists were to go further in this respect than the socialists of the Arts and Crafts movement, such as William Morris and Walter Crane; and the same individualism which led them to reject the conventions of official art led them to a profound concern with human suffering and deprivation which found expression in Anarchism or Communism. Indeed, the relationship between Expressionism and Communism still survives on both sides of the Iron Curtain.

In one of the most popular books of the *fin de siècle*, *Là-bas*, J. K. Huysmans describes Grünewald's Karls-

ruhe *Crucifixion* thus: 'Dislocated, almost dragged from their sockets, the arms of Christ seemed pinioned from shoulder to wrist by the cords of the twisted muscles. . . . The flesh was swollen, stained and blackened, spotted with flea-bites. Decomposition had set in. A thicker stream poured from the open wound in the side, flooding the hip with blood that matched deep mulberry juice. . . . The feet, spongy and clotted, were horrible; the swollen flesh rising above the head of the nail, the clenched toes, contradicting the imploring gestures of the hands, seemed cursing as they clawed at the ochreous earth.'

This expressionist prose, replete with horror, highly personal, full of chromatic adjectives, describes the work of a rediscovered artist who himself was one of the most significant forerunners of Expressionism. The movement was in fact greatly nurtured by the work of art historians such as Friedländer, whose exhaustive study of Grünewald appeared in 1907, of Mayer whose monograph on El Greco was published in 1911, and of others who at this period wrote about Hogarth, Bosch, Goya and Bruegel, all of whom represented elements in the expressionist tradition. At the same time, too, new precedents were provided by the discovery of irrational, 'primitive' art, of popular art, which owed nothing to cultured sensibilities, and of the traditions of caricature, which had always distorted objective reality to convey a message or sensation.

Fauvism

Expressionism, in the sense in which I have described it, has always been regarded as a Teutonic and Nordic phenomenon; but its appearance in modern painting is the result of a liberation of colour and form which took place in France, and which culminated in the short-lived but seminal style known as Fauvism.

When in 1906 the group which had gathered round Henri Matisse exhibited together as the Salon des Indépendants, it is little wonder that in terms of current conventional sensibilities, the art critic Louis Vauxcelles (who had a gift for assisting art historians of the future; he also coined the word 'Cubists') should have described them as *fauves* – wild beasts. As a coherent group it was remarkably short-lived, and virtually ended a year after its birth; most of its members went on to other styles, and of those who retained the original Fauve inspiration many became embedded in its mannerisms. But it represented the birth of the School of Paris, and shared (with Expressionism proper) the responsibility for creating the art of the twentieth century.

France was special. Since at least the time of Louis XIV, the arts there had been fostered by the State on a formidable scale, discussed by the intelligentsia with passion, explored by their practitioners with a vigour never consistently attained in any other European country. French painting, marked in the eighteenth century by elegance and visual sophistication, was characterized in the nineteenth by an evolutionary dynamism. Stimulated by the special social and cultural atmosphere of Paris, with its museums and galleries, its art schools, still working on the traditional *atelier* system, its closely-knit community of artists in constant social contact through the network of cafés, French painting evolved with a remarkable speed and diversity, establishing a dialogue which lasted for more than a century between the romantic and the classical, the hard and the soft, the emotional and the intellectual. The pattern which had been established in the contrast between Ingres and Delacroix persisted under many different guises.

The Impressionists in the 1870s had made the most spectacular contribution to what might be called the perceptual revolution, creating a new form of visual humanism by vindicating the primacy of

the individual sensibility. As a result, Impressionism was never consistent or homogeneous. Tensions between thought and feeling, between line and colour, between analysis and synthesis, were there all the time, expressed not only in the difference between, say, Sisley and Pissarro, but between phases in the work of single artists, such as Manet and Renoir.

The hunger for ordered structure was the most apparent of the disruptive elements, producing the Pointillism or Divisionism of Seurat and Signac, with its hieratic rigidity of structure and its dogmatic use of dots of pure complementary colours, and those architectural explorations of form which led eventually from Cézanne to Cubism. But its complementary antithesis was also very much present. The current was flowing strongly in the direction of emotional sensibility, in France as elsewhere. A generation which looked up to Baudelaire could not but be aware of the fact, and towards the last quarter of the century the desire to wring the last drop of sensation took the same shapes in Paris as it did all over Europe. Beneath the surface of conventional life there existed an 'underground' as active in its explorations as any which exists today. Drugs were endowed with a cultural cachet by readers of Poe, Coleridge and Baudelaire; alcoholism was as widespread in Montmartre and Montparnasse as it was in the deprived rural areas of France. There was a hunger for unmentionable vices and strange experiences; there was even a not unfamiliar passion for anarchism. An important Fauvist painter, Maurice de Vlaminck, once wrote: 'Painting was an abscess which drained off all the evil in me. Without a gift for painting I would have gone to the bad. What I could have achieved in a social context only by throwing a bomb, which would have led me to the guillotine, I have tried to express in art, in painting, by using pure colours straight from the tube. Thus I have been able to use my destructive instincts in

order to recreate a sensitive, living and free world.'

This romantic agony, as it took shape in the context of French culture, touched a wide range of artists. The music of Debussy and of Fauré throbbed with new excitements, and the theme of Salome as expressed in Oscar Wilde's verse drama attracted not only Aubrey Beardsley but Gustave Moreau, too often described as a traditional salon painter. 'Nature itself is of little importance; it is merely a pretext for artistic expression. Art is the relentless pursuit of the expression of inward feeling by means of simple plasticity.' These sentiments were the basis of Moreau's teaching, and his pupil Henri Matisse was to find them 'profoundly troubling'; they were to be the unavowed credo of Fauvism.

There were more apparent precedents. Vincent van 27 Gogh had never made any pretence that his art was other than the expression of inward feeling. 'I don't know if I can paint the postman *as I feel him*,' he once wrote to his brother Theo; and the fervour of his colour, the emotive violence of his forms, were having an impact which was emphasized by the first retrospective held at Bernheim-Jeune's gallery in 1901, at which Matisse was introduced to Vlaminck by another young painter, André Derain.

In 1889 Paul Gauguin, staying at Pont-Aven in Brittany, had been moving towards a style which would combine spontaneity, mysticism and a complete disregard for 'truth to nature' with the use of 6 non-descriptive colours, as exemplified in *The Yellow Christ*. The motivation may well have been literary and Symbolist; 'I find everything *poetic*, and it is in the dark corners of my heart, which are sometimes mysterious, that I perceive poetry,' he wrote to Van Gogh at this time. The stylistic origins lay in Japanese and primitive art, but the total effect was one of emotional excitation of the 'dark corners of the heart', 7 implying as time went by (*Contes Barbares* of 1902) a total independence of the artist from any terms

of reference except those of his own sensibilities.

The technical revolution which was under way was Expressionist in perhaps the purest sense of the word: it had no exclusive connection with any particular kind of subject matter, but was concerned with the direct use of colour and form, not to suggest but to express. It was a necessary step in the emancipation of art from literal depiction. The essence of what came to be known as Fauvism, which every painter interpreted in his own way, lay in the uninhibited use of colour to define form and express feeling. In Matisse's 3 *Nude in the Studio* of 1898, the purity, the violence of the colour conveys a sense of audacity that disguises the resolute quest for formal coherence, inherited from Cézanne, which he was never to abandon. There was clearly something in the air at the moment which transcended personal contacts and coteries, for in Barcelona, for instance, nineteen-year-old Pablo Picasso was painting pictures such as *The* 12 *Window* which showed the same tendency for forms to dissolve in, and be moulded by, evocative colour; in Picasso's case they were less pure, less adventurous, echoing the palette of Manet rather than venturing into new chromatic dimensions.

Personal contacts, however, were the flashpoint which ignited Fauvism. The common experiences of Moreau's studio were extended in 1899 at the Académie Carrière, where Matisse met two painters from the Paris suburb of Chatou, André Derain and the self-taught Maurice de Vlaminck, both of whom were making adventurous visual experiments in the same direction under the influence of Van Gogh. Vlaminck, an explosive, naturally gifted, physically vital man, an anarchist and a champion cyclist, who once said that he loved Van Gogh more than his own father, obviously owed something to his Flemish ancestry. Consumed with a passion for brutal truth, 13 he crucified his sitters with something approaching relish, handling paint with a Chardin-like verve.

Matisse was to build his subsequent career on his experiences and discoveries during this period, in which he produced some of his most spectacular
4 works. The continuing evolution of colour and its emancipation from accepted perceptual conventions led to an increasing concern with what he called 'pictorial mechanism', which owed a lot to the disciplines of Seurat's Pointillism: its structural purity and use of dots of pure colour. Abandoning realism, he kept a tangential hold on reality; and even in a
2 painting such as *Luxury I* he not only retained spatial depth, but arranged the figures in a composition which would not have been unfamiliar to an artist of the Renaissance. They are simplified, stylized, but not distorted for any emotive reason. At the same time, however, they convey perfectly the resonances of the title.

Among Matisse's associates in the early 1900s, the closest to him was Albert Marquet. From a style close to the bold formalism of Edouard Vuillard and the other members of the Nabi group of the 1890s, Marquet migrated to one which, though expressive in form and technique, eschewed the pure brilliant colours of Vlaminck or Matisse, and kept much
9 closer to figurative sources. In *Matisse Painting a Nude*, for instance, the colour appears rather as a background than as an integral part of the whole composition; the figure is defined by a line, and not modelled by the surrounding areas of colour. There is also apparent Marquet's growing concern with a subdued palette, and with the potentialities of a luminous black; in many ways he reverted to a Manet-like approach to painting, and his draughts-manship was such that Matisse once described him, with some pertinence, as 'the French Hokusai'.

André Derain brought to the Fauves something of the same vigour and panache as his friend Vlaminck; he too used colour directly from the tube, applied in broken lines with quick impetuous brush-strokes;

but even in his youthful works he was more lucid, more thoughtful, more graceful. Conscious of the past, his discovery of the emotive use of colour owed as much to the Pointillists as it did to Van Gogh, and his forms were influenced by a variety of precedents: *Images d'Epinal*, those simple folk-images which had so appealed to Courbet and Gauguin; Byzantine art; and the simplified planes of African sculpture. In 1905, the year in which he visited London and painted scenes on the Thames, he produced views of the Seine in which Seurat's Pointillist technique is allied to Van Gogh's hatched brush strokes to produce works of organized lucidity, remarkable for their emotional coherence.

18

Face to face with a living model, however, Derain's work took on greater immediacy; and in *Lady in a Chemise* he came close to the impetuous vehemence which was at the heart of Fauvism. The multiplicity of colours and tones, the flickering flame-like brushwork, the exaggeration of the face and eyes, the heavily pendulous and slightly distorted left hand, the partial use of a contour line to define those parts of the figure which play a dominant part in the composition, create an impression of adventurousness which in the long run turned out to be alien to his talent.

11

'How, with what I have here, can I succeed in rendering, not what I see, but what is, what has an existence for me, *my reality*, then set to work drawing, taking from nature what suits my needs? I drew the contours of each object in black mixed with white, each time leaving in the middle of the paper a blank space which I then coloured in with a specific and quite intense tone. What did I have? Blue, green, ochre, not many colours. But the result surprised me. I had discovered what I was really looking for.' The description which Raoul Dufy gave, many years later, of his conversion to the ideas of Fauvism, describes as well as anything the sense of elated emanci-

pation which so many of his contemporaries felt, and it is immediately apparent in his paintings of this period; they have a chunky vitality which his later, more graceful and sophisticated works were to lose 16 completely. *Placards at Trouville*, with its movement, its bold simplified outlines, its areas of bright colour, each emitting an air of joyous sensationalism, conveys perfectly the sense of seaside holiday-making in fresh sparkling air. Born at Le Havre, Othon Friesz studied at school under the same teachers as Dufy, and he too was fascinated by seaside subjects. His 17 *Sunday at Honfleur*, painted a year after Dufy's exercise at Trouville, emphasizes the differences between them. The composition is more static, the colour less adventurous, the lines heavier, more dominant; the desire to charge the canvas with some kind of lyrical emotion is more apparent, and therefore less successful. Friesz's thirst for visual eloquence was to lead him eventually to a baroque exuberance which verged on the hysterical.

The Fauve experience was for many artists a period of liberation, marking the moment at which they escaped from the conventions of realism and the confines of the conventional palette to achieve a realization, on which their future careers would be built, that the artist was concerned with the primacy of his own personal vision, and with creating a world which he himself controlled. This is especially evident in the case of Georges Braque, who was, like Friesz, a native of Le Havre. It was Friesz who first introduced him to what the Fauves were doing; and for some three years, between 1904 and 1907, he 1 produced a series of works which, though vivid in colour and exuberant in line, are thoughtful in composition, velvety in texture, and more deliberate in execution than the general run of paintings his friends were producing. Already there was implicit in them a concern with construction, a tendency to flatness of composition, which foreshadowed the

emergence of Cubism. But artists such as Robert Delaunay, who themselves were never Fauves, and who went on to Cubism, Futurism or any of the other subsequent movements which the Fauve revolt had made possible, always retained strong evidence of its influence in their works, paying unconscious tribute to its liberating force, and to the new significance which it had given to colour.

This was even more true of those artists whom one might define as unconscious Fauves, of whom the most outstanding example was Georges Rouault. A pupil of Moreau, and at one time marginally connected with Matisse's group, Rouault never really felt in sympathy with the movement, although he was equally concerned with wringing anguish from his colours, and using art as a means of expressing a personal, anti-realist viewpoint. The two dominant elements in his creative make-up were his early experiences as an apprentice to a maker of stained glass, and his friendship with two prominent figures in the Catholic revival which had such an important influence in the cultural life of the early twentieth century: J. K. Huysmans, a convert who united the fervours of belief with the recently shed languors of decadence, and Léon Bloy, one of the new school of writers who combined a radical concern about social justice with an almost excessive passion for the traditional values which he saw enshrined in Christianity. From these combined sources Rouault built up a style which varied little throughout the whole of his career. From his religious and social preoccupations he evolved an iconography which dealt with religious subjects, with whores and clowns, with all that involved the grandeurs and miseries of *la condition humaine*, and a passion tinged with bitter irony, even pessimism. From his feeling for the translucent beauty of stained glass he evolved a style characterized by its craftsmanship, its Byzantine simplicity, its luminous colours. But, in spite of these

personal mannerisms, Rouault was still at heart a Fauve. The sense of stylistic passion, the savage slashes of colour, the need for vehemence, become more apparent when, as in *Versailles: The Fountain*, the subject-matter is not overtly Expressionistic.

14

The extent of Rouault's Fauvism can be assessed by comparing his work with that of the happy, extroverted Kees van Dongen, an instinctive, archetypal Bohemian, who also had a penchant for painting clowns and the demi-monde, and whose finest work has an exuberant panache, an evocative passion, which seduce rather than convince. His momentary strengths and his eventual weaknesses sprang from the fact that he was a natural painter. A member of the Fauves, he later went on to join the German group Die Brücke (see p. 28), and in this context demonstrated the gulf which existed between those artists to whom passion in painting was a matter of style and those for whom it was a way of life.

8

A Northern Episode

The almost irresistible urge to identify the genius of Expressionism with that of Nordic cultures – and to relate its degrees of intensity to the distance which separated its practitioners from the shores of the Mediterranean and the influences of Catholicism – receives its most cogent support from the work and personality of Edvard Munch, whose paintings have become the very archetypes of all that the movement implied. A Norwegian, he was nourished in the same traditions which produced the guilt-tinged work of Ibsen and Strindberg (who wrote the catalogue entry to his *The Kiss*). Profoundly neurotic, his childhood was spent in the most inauspicious circumstances: his mother died when he was five, and one of his sisters when he was thirteen; his father was a doctor who practised in a poverty-ridden area of Löiten. He grew up in an atmosphere dominated by the ideas

of death, disease and anxiety, and the images of this period of his life were always to remain with him. In the *Madonna* of 1895–1902, for instance, the typically 'decadent' concept of the subject as a nearly nude, whore-like figure is reinforced by a painted border of spermatozoa, which lead to an embryo in the lower left-hand corner, derived from an illustration in a German anatomical text-book published in the middle of the century, and presumably forming part of his father's library.

Significantly enough, Aubrey Beardsley made use of the identical figure in several of his drawings; which underlines the fact that many artists who came to creative maturity in the later nineteenth century were obsessed with the same symbols, the same preoccupations. The concept of the *femme fatale*, using the phrase in its literal sense, to indicate the idea of woman as a malevolent, destructive and seductive siren, appears time and time again in the later work of Rossetti, in the paintings of Moreau, Redon and Klimt; in the drawings of Félicien Rops, Beardsley and Grosz; in the writings of Swinburne, Verlaine, Wilde. It was typified by the preoccupation with the theme of Salome, and it played a vital part in the work of Munch. Time and time again he reverts to the theme of woman as vampire, as the fatal temptress, and even in his *Madonnas* he seems intent on destroying utterly the icon which in the past had done so much to idealize femininity.

No less was he seduced by the idea of death and disease. In part this may have been due to the circumstances of his childhood; death struggles, sick rooms and the paraphernalia of mortality intrigued him as much as the themes of classical mythology had obsessed Poussin. But there was more to it than that. The idea of eventual personal annihilation has always been emotive, and the nineteenth century was more than half in love with easeful death. Queen Victoria was as susceptible to the idea as Munch, and in some

curious way – partly at least explained by Mario Praz – it had become intermingled with sexuality. Keats, Schubert, Schiller and many others had underlined the connection in the early part of the century; the Belgian Antoine Wiertz (1806–65) devoted his whole artistic career to the theme, and bequeathed to an ungrateful posterity a museum commemorating the fact. But nowhere – because he bent his technique to underlining his image – has the idea been better elaborated than in Munch's *Death and the Maiden* of 1893. On the left of the picture wriggle the spermatozoic shapes; on the right is a frieze composed of two foetus-like creatures. Death himself is no traditional Gothic-horror skeleton, though the black branch-like lines which echo his shape suggest the anatomical: he is a semi-human shape, full of amorphous ambiguities, the sense of horror emphasized by the wooden leg-stump which emerges through the girl's thighs. She, on the other hand, is characterized by an exuberant sensuality, underlined in a formal sense by the heaviness of her thighs, the solidity of her buttocks, the bluntness of her face, and the exaggeration of the line which runs from her left armpit to her knee.

That Munch had personality problems more pressing than those which beset the generality of mankind is obvious, and it would be ridiculous to disregard them in assessing the nature of his work. His neuroses are apparent in such a way that the work is often the graphic expression of actual experience. He was conscious of this, and in his diary he records the experience which created one of his most symptomatic subjects, *The Cry*. 'I was walking along the road with two friends. The sun was setting, and I began to be afflicted with a sense of melancholy. Suddenly the sky became blood-red. I stopped and leaned against a fence, feeling dead-tired, and stared at the flaming clouds that hung, like blood and a sword, over the blue-black fjord and the city. My

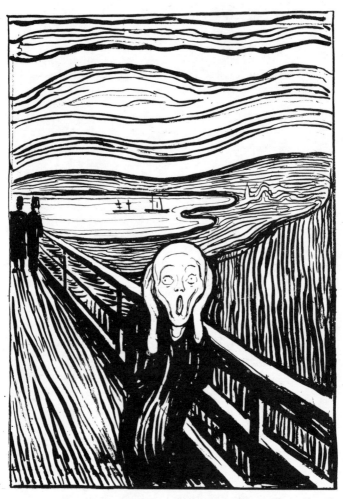

Edvard Munch. *The Cry*, 1895. Lithograph, $13\frac{3}{4} \times 9\frac{7}{8}$ (35.2 × 25.5).

friends walked on. I stood riveted, trembling with fright. And I heard (felt) a loud, unending scream piercing nature.'

The experience, then, although psychological in origin, was as real to him as to a mystic. But many have had similar sensations; what was in a sense unique about Munch was that within the traditional framework of the European artistic tradition, he forged a remarkably expressive – the adjective is inescapable – visual technique, combining the curved whiplash line of Art Nouveau with colours which range from the acidulous to the sentimental in a frenzy of compositional vigour which is often strongly reminiscent of Van Gogh. Nor is this stylistic affinity accidental. In 1889 Munch had travelled to Paris on a state scholarship and had come into contact with Van Gogh and Gauguin – the latter, as usual with younger artists, exerting a strong influence on him. In 1892 he was invited to exhibit at the Verein der Berliner Künstler, where, after a great deal of controversy which helped to impress Munch on the German artistic awareness, and led to the foundation of the Berlin Secession, the leaders of the society closed the exhibition in which he was participating. But it was in the German capital that he came into fruitful contact with the poet Richard Dehmel, the critic and historian Julius Meier-Graefe, the enlightened industrialist Walter Rathenau (who first bought a Munch painting in 1893) and Strindberg. By 1895 he was back in Paris again, and for the next few years lived a cosmopolitan existence, though forced to spend occasional periods in a sanatorium. In 1908 he suffered a complete collapse and spent a year in Dr Daniel Jacobson's hospital in Copenhagen. In 1909 he returned to Norway and passed the rest of his life there in relative seclusion.

Like his literary compatriots, Munch was preoccupied with feelings rather than objects, and above all else with their effects on people and their relation-

ships. In this latter respect he was unusual among the Expressionists. This is apparent especially in the contrast between his work and that of his Belgian contemporary James Ensor, with whom, in other respects, he has many affinities. Both were ecstatic in their approach; both concerned themselves with the dark underside of life; and yet both drew support and nourishment from the traditional elements of art – though this was more apparent with Ensor, whose affinities with Turner, and even with Chardin, need no underlining. Even physically they were rather alike. But the style is almost invariably the man, and Ensor seems through his Flemish mother to have established instinctive contact with the cultural tradition which she represented. It was derived not from the Italianate episodes of the seventeenth century as represented by Rubens, nor from the French-orientated style of the Walloons, but from a stream of uninhibited visual fantasy, interlaced with bucolic folklore, which, stretching back to the Middle Ages, had found its supreme expression in the works of Pieter Bruegel, and which, continuing into the twentieth century, has helped (largely through Belgian artists such as Magritte and Delvaux) to link Expressionism with Surrealism. Ensor marks, more clearly than any other artist, the line of continuity between the so-called 'Nibelungen Expressionists' – Hieronymus Bosch, Urs Graf, Hans Baldung Grien – and the artists of the late nineteenth and early twentieth century.

Satirical, compassionate, acerbic and whimsical, Ensor created a universe of his own, peopled with absurd, tawdry, moving, shocking figures which grip the imagination, stimulate the fancy and by their very vehemence produce just that shock to the susceptibilities of the spectator which is the prime goal of Expressionism. *Skeletons Warming Themselves at a Stove* might well be an epitome of the whole movement: the macabre theme, the sinister whimsicality

of the animated skeletons grouped grotesquely in a clumsy pyramid around the stove, the minatory figure in the right-hand corner of the composition. But despite the subject matter – and this is a consistent element in Ensor's work – the colouring has a light, sensuous quality, which verges on the lyrical, and underlines his debt to the Impressionists. It was only in his early phase that his technique verged on the sombre, and even then it had a delicate, velvety texture.

Skeletons Warming Themselves at a Stove looks almost as though it might be an illustration of some pungent, folksy proverb, and though Ensor was capable of painting pictures such as *The Ray* which have no meaning other than that conveyed by the form and colour, there are always literary and social implications in his major works. They are commentaries, even though the precise nature of the moral is never clearly indicated. This is especially true of the *Entry of Christ into Brussels*, which packs into one massive composition (250 × 434 cm) a whole host of satirical, grotesque episodes and situations. A great mass of ugly, distorted faces; Christ mounted on an ass; a broad banner with the inscription *Vive la Sociale*: the whole thing is like some mad *kermesse* portrayed in a manner which hints at a parody of a historical *grande machine* by a Baroque artist. Again, the colours are light, lyrical, but emphatically dissonant; and the substructure of drawing is marked by a deliberate coarseness – vulgarity would not be too strong a word – which underlines one of Ensor's greatest contributions to the vocabulary of Expressionism, the use of line to create an emotive effect independently of colour. It was this quality which especially endeared him to Paul Klee, and to Emil Nolde, both of whom derived a great deal from his influence. It is important to remember that Ensor produced his most significant work in the last twenty years of the nineteenth century – *The Entry of Christ*

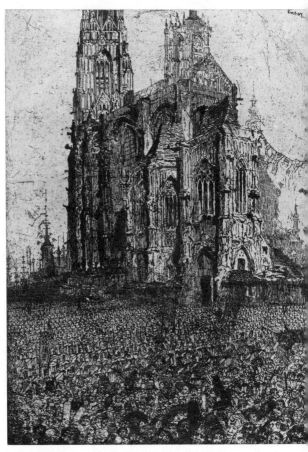

James Ensor. *The Cathedral*, 1886. Etching, $9\frac{1}{2} \times 7\frac{1}{2}$ (24.3 × 19.2).

into Brussels was painted in 1889 – and that, more forcibly than Gauguin, and even than Van Gogh, he assailed the primacy of the representational element in art, deriving his inspiration largely from that one area in which it had never played an important part – caricature. At the same time too his exploration of the

incongruous and the irrational anticipated developments which would not become apparent in the mainstream of art until the second decade of the twentieth century. Life, death, the absurd grandeur of the human condition, were themes which obsessed him, whatever the changes which took place in a style which showed at times the influence of Turner, of Constable and of Rowlandson (in the Royal Museum at Antwerp there are copies by him of works by all three of these). An assiduous student of the great printmakers and etchers (Rembrandt, Callot, Daumier and Forain were his favourites), he produced, especially in the 1880s, a great number of etchings (such as *The Cathedral*) and other monochrome works in which Goyaesque fantasy illumines disciplined skill.

He was subject to the ambiguities of his time, and though public recognition came late, he could well be claimed as a precursor by Fauves, Expressionists and Surrealists alike; while, equally, the Symbolists might have observed in his work strong elements of their own preoccupation with metaphysical references. He was, after all, the compatriot and largely the contemporary of Emile Verhaeren and Maurice Maeterlinck. His iconography with its strong allusive qualities would have been acceptable to artists who eschewed the violence of his technique, and his preoccupation with those imaginative resonances which were the concern of painters as disparate as Redon and Klimt is suggested by his concern with masks – as in the famous *Self-portrait with Masks*. The autobiographical source of these (as well as of his concern with shells and Chinese porcelain) was doubtless the stall which his mother used to run on the front at Ostend. But they came to possess for him an abiding significance, reflecting at once the psychic anomalies of his own life and the baffling enigmas of interpersonal relationships. Masked figures were almost a cliché of Symbolist art, but Ensor was the first to raise them to the status of independent

entities, suggestive question-marks in the carnival of life.

Although he was a co-founder of the avant-garde group Les XX, which exhibited Seurat's *A Sunday Afternoon at the Island of La Grande Jatte* in 1887, Ensor did not start to receive real recognition until the 1920s, by which time he had long done his best work. But he did play a significant part in forming the considerable tradition of Belgian Expressionism, itself a vital link in the transmission of all that the movement implied to later generations.

The links between Paris and Brussels had always been close, and a typical transitional figure was Rik Wouters, who, commencing as a self-taught artist, visited Paris, where he came under the influence of Degas and Cézanne, to whom, superficially, his style owes a great deal. But in his case what might have been little more than a kind of derivative Post-Impressionism was transformed, partly through the influence of Ensor, partly through the consuming passion which he felt for his wife Nel, into something much more dynamic, broad in handling, lyrically emotive in colouring, with passages of rich vibrancy which suggest the basic grammar of pure Expressionism.

For him there was never any precise moment of conversion; perhaps his life was too short for that, and a more typical figure was Gust de Smet, whose career illuminates the way in which the dormant inclination to Expressionism which was inherent in Flemish art could be triggered off by external stimuli into something closer to our conception of an international style. When in Holland he broke away from the luminist tradition which he had derived from the Impressionists, and, largely through the magazine *Das Kunstblatt*, became familiar with what was happening in Germany. His art became wilder, more tragic, the brushwork quick, nervous, ecstatic, with sombre earthen colours, and he chose for his subjects

those emotion-laden themes – prostitutes, circus people, peasants – which had come to be accepted as the accredited icons of twentieth-century romanticism. After flirting for a while with the structural dynamics of Cubism, he reverted in the 1930s to paintings in which the sonorous play of light and colour within a clearly defined outline evokes a sense of passionate sensuality.

If Bruegel was Flemish, so too was Rubens, and the particular brand of Expressionism which dominated Flanders for the first quarter of this century was on the whole humane rather than violent, lyrical rather than vehement; an Expressionism of the brush rather than of the heart. This was as true of De Smet as it was of his friend and contemporary Constant Permeke, who also started off his artistic career in the Impressionist-inclined artists' colony of Sint-Matens-Latem, and then developed an emotive monumentality which retained Ensor's sense of near-abstraction and visual violence. Objects ceased to be clearly visible, and were discernible rather than apparent; there was a largeness of treatment, an air of the cosmic about both his figures and his landscapes. Wounded in the war, Permeke lived for five years in considerable poverty among the farmers of Devonshire, an experience which confirmed in him that penchant for a kind of rural mysticism which was one of the minor strands in the Expressionist tradition, deriving its sanction from both Van Gogh and the Pont Aven school. The sense of lyrical rapture infuses his paintings with a Turneresque quality which may have been consciously acquired in England, but more directly it permits the unification, within a single composition, of a whole variety of disparate objects – trees, houses, windmills – which assume a limpid plasticity within an all-embracing light.

Léon Spilliaert, although self-taught, was formally more sophisticated, his art more elusive. Untouched by Ensor, but owing much to Munch, his earliest

works have strong Symbolist characteristics, the linear arabesques which dominate them suggesting an impassioned Art Nouveau with emotional undercurrents alien to that more purely decorative style. But from the very beginning, his paintings had an unreal, hallucinatory quality, and certain images obsessed him – girls by the seaside, human beings confronting and being absorbed by nature. Trees came to play an increasingly dominant role in his imagery, and he observed them with a frenzied intensity which converts them from inanimate phenomena into brooding totems, transforming their surroundings into landscapes of the mind heavy with hidden significances. More clearly than any of his contemporaries, he shows the intricacy of the network which linked Symbolism, Expressionism and Surrealism.

Germany: Die Brücke

A good deal of the impetus which Expressionism in Belgium received came from the presence there during the Great War of a number of German artists, most of them working in a medical unit. Erich Heckel, for instance, was stationed in Ostend, came into contact with Ensor, and painted his lost *Ostend Madonna* in 1915 on the canvas of an army tent. This underlines the fact that although Expressionism was a European phenomenon, it was in Germany that it achieved hegemony. It was there that it became almost a way of life, and it was there that it assumed its most radical and influential forms. The reasons for this cannot be restricted to mere stylistic evolution or changing aesthetic credos. Dangerous though it may be to make generalizations about the pattern of national cultures, it seems impossible to evade the realization that of all European peoples, the German-

speaking have been the most apt to emphasize feeling, to prefer the world of the imagination to that of fact, to be seduced by the concept of storm and stress, to toy with ideas of darkness and cruelty. This was no new thing. The sadistic iconography of Grünewald, the violence of popular German art, especially in the field of graphic reproduction; the fact that, for instance, of the seven 'horrid' novels Jane Austen mentions in *Northanger Abbey* two are actual translations from the German, and four others are set in Germany; the popularity of stories such as that of *Struwwelpeter* all point to a continuity of interest in the macabre. John Willett, in his lively history of Expressionism, makes the point that the poet Johannes Becher, a leading figure in literary Expressionism, who became Minister of Culture in East Germany in 1954, could quote with immense approval this passage from the seventeenth-century poet Andreas Gryphius:

Oh the cry!
Murder! Death! Misery! Torments! Cross! Rack!
 Worms! Fear!
Pitch! Torture! Hangman! Flame! Stink! Cold!
 Ghosts! Despair!
O! Pass by!
Deep and high!
Sea! Hills! Mountains! Cliff! Pain no man can bear!
Engulf, engulf, abyss! those endless cries you hear.

Reinforced by its self-imposed function as the guardian of the West against the Slavonic hordes, nourished by the horrors of the Thirty Years War, the German spirit alternated between apocalyptic idealism and intellectual masochism. The patterns of history did little to relieve these tensions. Between its beginnings as a united nation in 1870, and the advent of Hitler some sixty years later, it endured the hysterical imperialism of the Hohenzollerns, the

privations of the Great War, the miseries of inflation, the tragedies of the Weimar experiment. Catastrophe or the millennium seemed always to be on the horizons of German experience. The music of Wagner and of Richard Strauss; the writings of Nietzsche and Heinrich Mann; the plays of Strindberg (which were very popular in Germany) and Wedekind, all nourished that sense of revolutionary emotional turbulence which drove the artists of Berlin, Munich, Dresden and Vienna far beyond the limits reached by their more restrained contemporaries west of the Rhine. In Germany, to an extent unknown in any other country, Expressionism dominated painting and sculpture, literature, the theatre and the cinema.

Unlike France, with its strong traditions of unified political history and centralization, Germany still retained that regionalism which the creation of the Empire under Prussian rule had hidden rather than destroyed. Although the first stirring of a new movement in the arts was nourished by the presence in Germany during the 1890s of Munch who had a *succès de scandale* at the exhibition of the Verein der Berliner Künstler (a dominantly Impressionist body) in 1892, and by the steadily widening influence of Gauguin and of Van Gogh, its final realization was regional rather than national.

Die Brücke ('The Bridge'), which has justly been described as commencing more like a revolutionary cell than an art movement, was founded in 1905 by four refugees from the school of architecture at Dresden, the capital of Saxony. They had no experience of painting, but they saw in it a means of liberation, a medium for expressing a social message. In the programme which one of them, Ernst Ludwig Kirchner, composed and engraved on wood for the group in 1906, he wrote:

'Believing as we do in growth. and in a new generation, both of those who create and those who enjoy, we call all young people together, and as

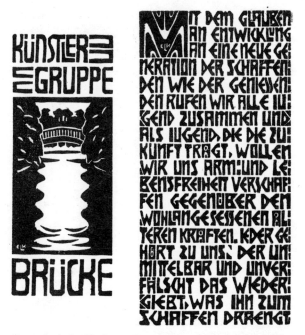

Ernst Ludwig Kirchner. *Programme of Die Brücke*, 1905. Woodcut.

young people, who carry the future in us, we want to wrest freedom for our actions and our lives from the older, comfortably established forces. We claim as our own everyone who reproduces directly, and without falsification, whatever it is that drives him to create.' Influenced by Van Gogh, by medieval German woodcuts, and by African and Oceanic sculpture, Kirchner was concerned with exploiting every technical and compositional technique which could convey a sense of immediate vivid sensation, mixing petrol into his oil paints so that they dried quickly with a matt finish, excelling in watercolour, often in conjunction with other media, applying bright local colour with small brush strokes. His

chromatic inventiveness was, within his own context, remarkably revolutionary: he would harmonize reds and blues, black and purple, yellow and ochre, brown and cobalt blue. Indeed all his earlier works document the self-education of an artist untrammelled by the precedents of formal education.

By 1911, therefore, when he and his friends decided to move to the more metropolitan atmosphere of Berlin, Kirchner had acquired considerable technical skills, designed for his own purpose, but had not yet lost a certain innocence of visual approach. All this is summed up in *Semi-nude Woman with Hat*, painted in that year. Broad and simple in conception, parsimonious almost in its range of colours, it is a simple dynamic composition, depending on the use of contrasting and complementary arcs. One series starts with the top of the hat and is continued through the shoulders and arms. Another commences with the brim of the hat, is half-echoed in the chin, doubled in the breasts, and concludes with the lines of the blouse. As a counterpoint to this theme is another, consisting of triangles; the first in the lower section of the hat where it reveals the woman's forehead, the second, inverted at the throat, is echoed in the armpits and the fingers of her left hand. The broadly brushed-in background serves as a counterfoil to the figure, whose face, while it suggests the influence of primitive sculpture, is also marked by a kind of suggestive eroticism. The Expressionists as a whole were to be enamoured of the Brechtian underworld of Berlin, with its whores, pimps and gangsters who contrasted so strongly with the apparent simple purity of their own dreamworld. How powerful the effect was on Kirchner is especially apparent in works such as *Five Women in the Street*, in which the ominous black figures, with their sinister, elongated bodies and fantastic hats, are sited against a virulent green background, which, though it retains a few elements of figurative observation, is virtually

abstract and of considerable compositional complexity. Sculptural influences are again apparent; but the whole painting is massively dedicated to representing the artist's own sense of projected sin, Puritan in intention, passionate in expression. Significantly, five years later, when on the verge of physical and mental collapse, he wrote; 'I stagger to work, but all my work is in vain, and the mediocre tears everything down in its onslaught. I'm now like the whores I used to paint.'

After his breakdown he went to Switzerland, and there found annealing but less emotive themes in the contemplation of landscape, and in the idealization of those peasants of Davos whose staple industry for the last century seems to have been the inspiration of neurasthenic Northerners. Though still showing a certain violent grandeur of conception, his post-war works never really lived up to the earlier works, with their overriding sense of passionate apprehension.

Erich Heckel was in some ways more restrained than the other members of Die Brücke, even though his technique was occasionally more adventurous. His first paintings have the uncontrolled vehemence of the newcomer overwhelmed by the freedom which art gives him, intoxicated by the sense of apparently limitless power which it seems to confer on its practitioners. *Brickworks* of 1907, for instance, has been painted by squeezing oil out of the tubes straight on to the canvas, and using the brush only to tidy up the total effect. Colours and forms swirl together in a kind of pictorial storm. The visual impact – an extremely moving one – has nothing to do with the actual theme; it is created entirely by the medium, which has a life and movement all of its own. The pure, undiluted pigment has the same vehemence as in some of Van Gogh's paintings.

There was something touchingly idealistic – and German – in Heckel's devotion to the concept of the group to which he belonged at this period – reminis-

cent both of the ideals of the nineteenth-century Romantic religious painters, the Nazarenes, and of the less admirable duelling clubs. It was he who procured their communal studios and organized their first exhibition and their shared holidays on the Moritzburg lakes. In 1909 Heckel travelled extensively in Italy, was impressed by Etruscan art, fascinated by the idea of light, and set out to express in his work those qualities of formal coherence which he had discovered south of the Alps. The first fruit of this new inclination, and possibly his finest

49 painting, is the *Nude on a Sofa*, in which the singing colours and gently hedonistic image are set off by the vigour of the composition and the nervous, ecstatic brushwork. At first glance it is closer to the Fauves than to their German Expressionist contemporaries, but no Frenchman would have been quite so peremptory in his treatment of the feet, nor so emotive in the handling of the walls and window. In a sense, *Nude on a Sofa* exemplifies perfectly Kirchner's clarification of the original Brücke declaration: 'Painting is the art which represents a phenomenon of feeling on a plane surface. The medium employed in painting, for both background and line, is colour. The painter transforms a concept derived from his own experiences into a work of art. He learns to make use of his medium through continuous practice. There are no fixed rules for this. The rules for any given work grow during its actual execution, through the personality of the creator, his methods and technique, and the message he is conveying. The perceptible joy in the object seen is, from the beginning, the origin of all representational art. Today photography reproduces an object exactly. Painting, liberated from the need to do so, regains freedom of action. Instinctive transfiguration of form, at the very instant of feeling, is put down on the flat surface on impulse. The work of art is born from the total translation of personal ideas in the execution.'

In fact, in becoming more surface-orientated, Heckel's work, with its geometricized transcriptions of light and form, its sharp, angular contours and its figurative stylization, became the virtual standard of the Brücke contribution to the art of the twentieth century. It is nevertheless exceptional in possessing strong human sympathies, which have nothing to do with social protest, and an interest in narrative which secured him a considerable degree of popular success long before his fellow members achieved it.

Karl Schmidt-Rottluff, the third member of Die Brücke, and the one who invented the name 'The Bridge' – the implication was that it provided a link which held the group together, and led into the future – was in some ways more single-minded than either of the other two. For several years figures hardly ever appeared in his paintings. Introverted and reserved, often in a state of latent hostility to some of his fellow-members, his bold vigorous handling, vehement at times to the point of coarseness, his heavily saturated colours and large undefined compositional areas, brought him to the brink of pure abstraction. He was impassioned by the sea, and a determinant influence on his art was the landscape of Norway, which he visited frequently. Emil Nolde (see below), whom he introduced to the group, had helped him to achieve that transition from Impressionism which was an almost essential episode in the development of any Expressionist, but it was the move to Berlin, with its wider horizons, its more explicit literary interests, which led him away from landscapes to figures and still-lifes, to a more precise definition of the subject-matter, to a more fragmented and complex form of composition, with the landscape reduced to a series of two-dimensional symbols (as in *Summer*) against which the human figures appear as almost primeval statues.

After the war Schmidt-Rottluff's work became more lyrical, less vibrant, and he took refuge in

religious transcendentalism from the barbarism of his age, moving to a kind of Symbolism with strong literary and theological undercurrents. This was a common enough pattern at the time. Similar conversions had affected the Decadents and other writers and artists, who, relying initially too much on the absolute validity of their own sensations, had tended to react violently in the opposite direction when the inevitable disillusionment came. Forbidden to paint by the Nazis, who confiscated his works, he was appointed in 1946 to a professorship at the Berlin Hochschule für Bildende Kunst.

Emil Hansen, who in 1901, at the age of thirty-four, changed his name to Nolde, was both the outsider and the professional of Die Brücke. In 1898, while a drawing teacher at St Gallen in Switzerland, he decided to become a full-time painter, and went to study with Adolf Hölzel at a small village near Munich which bore the still-innocent name of Dachau. A Czech by birth, Hölzel was, through his teachings and writings, a figure of seminal significance in the evolution of contemporary art. Deeply interested in problems of colour harmony, preoccupied with using natural forms as the basis of a visual vocabulary, his writings had a strong social bias, and he was one of the main contributors to the significantly titled magazine *Die Kunst für Alle* ('Art for All'), which was widely read throughout Europe.

After his contact with Hölzel, Nolde spent some time in Paris, where he was greatly impressed by the works of Daumier and Manet. Gradually his Impressionistic technique widened under the combined influence of Gauguin, Van Gogh and Munch, and by 1904 he was using brilliant colours, laid on with an ecstatic disregard for the conventional techniques of brushwork. These paintings inevitably attracted the attention of the much younger artists of Die Brücke, who asked him to join them, and he took part in the group exhibitions of 1906 and 1907. But he felt that

the group was too confined, too inhibiting, and tried to start a rival association, more broadly based, and including Christian Rohlfs, Munch, Matisse, Max Beckmann and Schmidt-Rottluff. This was abortive, and equally unsuccessful was his attempt to take over the leadership of the Neue Sezession in Berlin in 1911. Some forty years later he wrote: 'Munch's work led to the founding of the Berlin Secession, my work to its splitting and dissolution. Much sound and fury, both at the beginning and the end. But all these irrelevancies soon pass; the essential alone remains, the core – art itself.'

It is difficult to understand Nolde's artistic career without paying attention to the deep pietistic side of his character. Sprung from a simple farming background, he was in full accord with that religious undercurrent which influenced men as disparate as Van Gogh and Bloy; and once he confessed to his friend Friedrich Fehr; 'When I was a child, eight or ten years old, I made a solemn promise to God that, when I grew up, I would write a hymn for the prayer book. The vow has never been fulfilled. But I have painted a large number of pictures, and there must be more than thirty religious ones. I wonder if they will do instead.'

It was mainly to religious themes that he turned when he reverted to figure painting in about 1909, having rejected it at the point of his conversion from Impressionism. But though in works such as *The Last Supper* of 1909 his figures are realistic in appearance, by the following year they are translated in 56 *The Dance Round the Golden Calf* into hieroglyphs of Dionysiac ecstasy, violent in colour, jagged in shape, dominating a landscape which retains the abstract qualities of his first excursions into the Expressionist idiom. The outlines of the forms are defined by the edges of the areas of colour, so helping to build up an air of almost uncontrolled hysteria. Believing absolutely in the validity of the instinctive reaction, the

personal vision, Nolde's own aesthetic credo expressed perfectly the romantic egocentricity of the Expressionist stance: 'None of the free imaginative pictures that I painted at this time [*c.* 1910], or later, had any kind of model, or even a clearly conceived idea. It was quite easy for me to imagine a work right down to its smallest details, and in fact my preconceptions were usually far more beautiful than the painted outcome; I became the copyist of the idea. Therefore I liked to avoid thinking about a picture beforehand. All I needed was a vague idea about the sort of light arrangement and colour I wanted. The painting then developed of its own volition under my hands.'

Nolde was probably more deeply concerned with the implications and significance of primitive art forms than were his younger contemporaries. He began work on a book, *Kunstäusserungen der Naturvölker* ('Artistic Expressions of Primitive Peoples'), and in 1913 was invited to join an official expedition to the German colonies in the Pacific, including New Guinea. From this experience he not only derived new sanctions for his expression of what he described as 'the intense, often grotesque expressions of force and life in the most basic form', but came into contact with landscapes and climatic conditions more violent than any he could have seen in Europe. *Tropical Sun* of 1914, which comes close to the kind of work Wassily Kandinsky was producing at about the same time, combines the sharp impact of intensely disturbing colours with forms which have a suggestive, cosmic, almost primeval vehemence.

After the outbreak of war, Nolde withdrew very largely from the contemporary art scene, and the first big exhibition of his work took place in 1927, when he was sixty, with Paul Klee providing the introduction to the catalogue. In this he wrote: 'Abstract artists, far removed from this world, or fugitives from it, sometimes forget that Nolde exists.

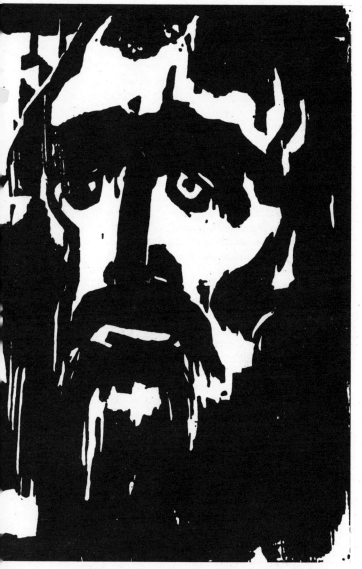

Emil Nolde. *The Prophet*, 1912. Woodcut, $12\frac{5}{8} \times 8\frac{5}{8}$ (32 × 22).

Not so I. No matter how far I may fly away from it I always manage to find my way back to earth, to find security in its solidity. Nolde is more than of the earth; he is its guardian spirit. No matter where one may be, one is always aware of one's kinship with him, a kinship based on deep immutable things.'

Nolde too suffered greatly under the Nazis, but received some degree of official rehabilitation by receiving the prize for painting at the 1952 Venice Biennale, four years before his death.

Max Pechstein had been an extremely successful student of decorative art before he joined Die Brücke in 1906, and in the following year he was awarded the Rome prize for painting by the Kingdom of Saxony. He was above all else a professional, resolved, for economic and psychological reasons, to make a success of his chosen occupation. No innovator, comparatively untouched by the wilder waves of aesthetic passion which buffeted his contemporaries, he used their discoveries to evolve a style of painting which combined brightness of palette, freedom of line, and freshness of approach with decorative decorum. And this was no bad thing. Every art movement needs men such as Pechstein who can mould its discoveries and innovations into an acceptable visual syntax; Raphael did something of the sort for the Renaissance, just as Pissarro did for the Impressionists, and Dufy and Van Dongen for the Fauves. Like Nolde, Pechstein went on a trip to the Pacific, but it neither exacerbated his sensitivities nor inflamed his emotions. Paintings such as *Nude in a Tent*, one of the many he produced in the course of his yearly summer holidays at Nidden on the Baltic, suggest the elegance of his line, the delicacy of his colour. His motivations were too trouble-free for him ever to have achieved the agonized vulnerability of his colleagues. 'I want to express my desire for happiness. I do not want to be ever regretting missed opportunities. Art is . . . the part of my life which has brought me the greatest joy.'

Otto Mueller, like Nolde, was older and more experienced in the arts when he joined Die Brücke than were Kirchner, Schmidt-Rottluff or Heckel. Supposedly of partly gypsy extraction (Romany themes were to have a special attraction for him), he commenced as a lithographer, and then studied painting at the Dresden Academy. The most important formative influence on him during his early years was that of the writers Carl and Gerhart Hauptmann, whose works had close affinities with literary Expressionism, and with whom he travelled extensively in Italy and elsewhere. He was also greatly attracted by the paintings of the Swiss artist Arnold Böcklin, whose dream-like fantasies, replete with strange emotional undertones, had an important influence on all those artists who effected the transition between nineteenth-century empiricism and twentieth-century subjectivism. Kirchner wrote in his journal: 'If one now traces Böcklin's work in Basle from its beginnings, one finds such a pure line of artistic development that one cannot but acknowledge his great talent. It progresses confidently, without divergence or hesitation, straight from value painting to coloured two-dimensionalism. It is the same path that Rembrandt took, and the moderns such as Nolde or Kokoschka, and it is probably the only right path in painting.'

Mueller's own works during this period – he later destroyed most of them – seem to have been predominantly Symbolist in content, if not in form, and he was very conscious of Egyptian influences. In 1910, he joined Die Brücke at the age of thirty-six. By then his style had become more or less fixed. His favourite theme was the female nude, which he treated without a great deal of distortion; his colouring was subdued, almost at times monochromatic, and this feeling of nostalgic reticence was enhanced by his concern with securing a fresco-like effect, mainly by the use of coarse canvas and various

32

combinations of oil paint, gouache and glue. On the whole Mueller's work has much of the decorative nature of Pechstein's, and he played a similar role in disseminating the visual discoveries of artists more radical than himself.

Germany: Der Blaue Reiter

By comparison with Die Brücke, the other important group of German Expressionists, Der Blaue Reiter ('The Blue Rider') was larger, more amorphous, more changing in its membership, but more ideological in its approach, more concerned with exploring man's relationship to his world; and so in the long run its members tended to have greater influence in the avant-garde. Several of them – Klee and Kandinsky are the obvious examples – went on to explore new visual territories and open up new dimensions of experience. The name of the group originated in a conversation between two of its founders. In 1930 Wassily Kandinsky recalled: 'Franz Marc and I chose this name as we were having coffee one day on the shady terrace of Sindelsdorf. Both of us liked blue, Marc for horses, I for riders. So the name came by itself.'

It is hard to disentangle all the manoeuvrings and dissensions among the young artists of Munich which led to the foundation of the group. Kandinsky had been painting and teaching in that city since 1896, and had been the main driving force in the creation of various progressive groups, but when in 1911 one of these rejected his *Last Judgment*, he and Marc founded Der Blaue Reiter, which held a series of exhibitions in Munich and Berlin and published an 'almanac' or year book, *Der Blaue Reiter*, whose one and only issue included essays and reviews about all the arts, and numbered among its contributors Schönberg, Webern and Berg, and among its illustrations, folk art, childrens' drawings and works by

Cézanne, Matisse, Douanier Rousseau, the Brücke group, Van Gogh and Delaunay. Indeed, Der Blaue Reiter was cosmopolitan in its membership and affiliations, including in one or other of these categories Russians such as Mikhail Larionov and Natalia Goncharova; Frenchmen such as Braque, Derain, Picasso and Robert Delaunay; and the Swiss Louis-René Moilliet and Henry Bloè Niestlé.

But, whatever stylistic allegiances Der Blaue Reiter commanded, and however divergent the paths which its members later followed, it was in its conception and short life – the group dispersed in 1914 – essentially German in origin, Expressionist in nature. In the *Prospectus* to the catalogue of the first exhibition at the Thannhauser gallery in Munich we find another statement of those familiar ideals: 'To give expression to inner impulses in every form which provokes an intimate personal reaction in the beholder. We seek today, behind the veil of external appearances, the hidden things which seem to us more important than the discoveries of the Impressionists. We search out and elaborate this hidden side of ourselves not from caprice nor for the sake of being different, but because this is the side we see.'

But by and large, the members of Der Blaue Reiter were more rigorous and more searching in their attitudes than were most of their contemporaries. They investigated colour theories, became concerned with problems of perception, flirted fruitfully with the physical sciences (Kandinsky owed much to the microscope), explored imaginary space and declared their independence of the boundaries of the visible world. Deeply influenced by the philosophical speculations of Wilhelm Worringer, whose *Abstraktion und Einfühling* ('Abstraction and Empathy') was published in 1907, several of them wrote persuasively in creative forms. Their approach to art was interdisciplinary in a way which had not been seen since the Renaissance.

Wassily Kandinsky was born and educated in Russia, and having in 1895 been converted to art by seeing an exhibition of the French Impressionists in Moscow, came to Munich, to devote himself entirely to painting, at a time when that city was the centre of the so-called New Style of art in Germany. He expressed himself in a wide variety of media (forecasting in his concern with the decorative arts his future involvement with the Bauhaus), designing clothing, tapestries and handbags. His painting was at this point predominantly Art Nouveau with Symbolist undercurrents, but already possessing allusive, emotive qualities. Travelling extensively, he was widely recognized, and he received medals in Paris in 1904 and 1905, was elected to the jury of the Salon d'Automne, and won a Grand Prix in 1906.

But during this period stronger, more vital impulses began to be apparent in his work. He digested the influence of Cézanne, Matisse and Picasso; he began to understand the value of Bavarian folk art; his colours began to sing; visible shapes began to lose their descriptive qualities. In paintings such as *On the Outskirts of the City* of 1908 the actual subject matter is of slight importance; indeed, it is positively irrelevant. What matters is the sense of dynamism which controls the cumulus-like groups of strongly contrasting colours; 'Houses and trees made hardly any impression on my thoughts. I used the palette knife to spread lines and splashes of paint on the canvas, and make them sing as loudly as I could. My eyes were filled with the strong saturated colours of the light and air of Munich, and the deep thunder of its shadows.'

This was a crucial moment in the history of modern art. The Dionysiac freedom of Expressionism was being suffused with another element, the metaphysical tradition of Russian Byzantinism, with its strong anti-naturalistic, hieratic tendencies. From 1910 onwards Kandinsky continued painting pictures

47

in which representational elements were still discernible; but side by side with these were works such as the *Large Study* of 1914, in which forms as well as colours have taken off into a world of their own, owing little to any recognizable visual phenomena – even though he did find some difficulty in creating an entirely abstract iconography. In the famous apologia which he published in 1910, *Über das Geistige in der Kunst*, ('Concerning the Spiritual in Art'), he used the word *geistig*, usually translated as 'spiritual', to describe the unreal elements in his paintings; perhaps today we would incline towards translating it by some adjective involving a suggestion of the psychological. These whirling shapes move across the canvas like dancing Dervishes, suggesting impulses deeper than those 'emotional' impulses which powered the main stream of Expressionism. His subsequent career indicated the extent to which he was constantly motivated by the desire to achieve a synthesis of thought and feeling, science and art, logic and intuition.

All his achievements were rooted in the original liberating experience of Expressionism, but there were others, less cosmopolitan in their upbringing, less vigorous in their empiricism, who never shook off their early dependence on a framework of naturalistic references. Whether this would have been true of Franz Marc it is impossible to say; he was killed at Verdun in his mid thirties, at a moment when he seemed to be reaching a point of evolution which his friend Kandinsky had arrived at a few years earlier. There was a strongly obsessive quality about his imagination, perhaps not unconnected with his religious preoccupations. He had started off as a theology student before turning to painting, which he looked upon as a spiritual rather than a worldly activity. Bowled over by Impressionism, he devoted himself for several years to the study of animal anatomy, and even gave lessons on the subject.

Although these studies were undertaken primarily
to evolve general principles of form from the close
examination of the particular, they assumed a special
emotional significance for him in his devotion to the
horse – that symbol so loved by advertising agents
and adolescent girls. To him animals came to repre-
sent a sort of primeval purity, each signifying some
45 admirable strength or desirable virtue: the deer
46 fragile agility, the tiger restrained, latent strength.
Although at first he painted animals in the foreground
of his pictures, later they became integrated with the
landscape, as though he were seeking a complete
identification of both.

Having secured expressive forms, he went on,
40 under the influence of his friend August Macke,
another member of Der Blaue Reiter, who of all the
group came closest to the Fauves, to explore the
emotional potentials of colour. 'If you mix red and
yellow to make orange, you turn passive yellow into
a Fury, with a sensual force that again makes cool,
spiritual blue indispensable. In fact blue always finds
its place inevitably at the side of orange. The colours
love each other. Blue and orange make a thoroughly
festive sound.'

The sexual undertones, the rather childish symbol-
ism, the strong sense of personalization – all are
typical of Marc, and of his generation. His colour
experiments were leading to a dissolution of form
similar to that being achieved by Kandinsky, when
his death cut them short.

Like Kandinsky a Russian by birth, Alexei von
36 Jawlensky was closely associated with Der Blaue
Reiter, but did not participate in any of their joint
exhibitions. Though he was later to grow close to
Nolde, the formative influences on his work up to
about 1912 were those of Gauguin, Matisse and Van
Dongen. His warm and passionate painting depended
largely on simplification, brilliant colours held within
dark contours, and a bounding sinuous line, which

gives a hieratic unity to the whole composition. The impact of the war led to an exaggeration of that taste for religious mysticism which he shared with Marc and others. 'Art' he said 'is nostalgia for God', and after 1917 the bulk of his work consisted of *têtes mystiques* – abstract head forms.

Although Expressionism in general, and the Blaue Reiter (in whose exhibitions he participated) were of great importance in the development of the art of Paul Klee, his approach to both was tentative, marked by that sense of hesitation which characterized the whole of his early career. Right from the beginning he had been, by instinct as it were, a linear Expressionist, producing graphic forms which paid little attention to naturalistic conventions, and which were bent or distorted to convey a sense of whimsical irony, even of a gentle sadism – emphasizing the debt which non-realist art owed to the traditions of caricature. Line for him was an independent structural element which he deployed to express strong sensations. But his contacts with Der Blaue Reiter led him to assume enough courage to explore the potentials of colour. He took the final step in 1914 when on a trip to Tunisia with Macke and Moilliet. It was the outcome of a long process rather than a moment of sudden conversion. In effect, he was an introvert who schooled himself to become an extrovert, a classicist who turned to romanticism (he always confessed to preferring Cézanne to Van Gogh). But, even so, it was in the compromise medium of watercolour that he was happiest, and that he made the most advances. In works such as *The Föhn Wind in the Marcs' Garden* of 1915, perfunctory gestures to perspectival space can still be seen, and he was never completely to renounce references to objective reality; he regarded it as a source of materials from which to create a personal imagery rather than as a model to be copied. Complex, subtle and lyrical, the picture is composed of roughly geometric sections each con-

44

taining its own colour, the different shapes forming a contrapuntal flat pattern which moves up and across the surface of the paper.

At the opposite pole of Expressionism, but within the same milieu, Alfred Kubin represented a tradition very different from the delicate happy fantasies of Klee. Mainly an illustrator, his imagination was nurtured on the morbid, and he gave shape to the nightmares of anxiety in a style which owed something to Beardsley, something to Goya, and a good deal to Odilon Redon. The author of a strange novel, *Die andere Seite* ('The Other Side'), he reasserted in the twentieth century the 'Gothic' traditions of the early nineteenth.

Der Sturm: Berlin and Vienna

It would be wrong, of course, to think of the experiments of Die Brücke and the Blaue Reiter as the sole manifestations of the new visual romanticism which was sweeping through the German-speaking countries. In both Berlin and Vienna powerful Secession movements – anti-academies, beset by schisms – gathered the progressive elements in the arts into an uneasy alliance. Not all of these elements, even within the Expressionist idiom, would have subscribed to the radical theories of Kandinsky or Marc, and within the pages of art journals such as Herwarth Walden's *Der Sturm* (which was largely reponsible for publicizing the notion of Expressionism as a movement) bitter controversies raged about the extent to which traditional attitudes should be accepted or rejected. A typical figure in this context was that of Max Beckmann, who commenced as an instinctual Expressionist working in a style which owed a good deal to Munch and even to Delacroix, and taking as his themes subjects such as his mother's deathbed, the Messina earthquake of 1910, or the sinking of

Alfred Kubin. *Pen Drawing for the 'Almanach der Blaue Reiter'*, 1911.

the *Titanic*. He emphasized, especially in the course of a lengthy controversy with Marc, which appeared in the magazine *Pan* in 1912, the traditional qualities of paint: 'Appreciation for the peach-coloured sheen of skin, the glint of a nail, for what is artistically sensual; for those things such as the softness of flesh, the gradations of space, which lie not only on the surface of a picture, but in its depths. Appreciation too for the attraction of the material. The rich gloss of oil paint which we find in Rembrandt, in Cézanne; the inspired brushwork of Frans Hals.'

A conversion which no aesthetic dialectics could bring about was effected by his traumatic experiences as a medical orderly – experiences which not only caused him to have a nervous breakdown, but also made his style into a medium appropriate for expressing their bitter content. The tormented anguish of 37 the *Self-portrait with a Red Scarf* of 1917 is expressed not only in the appearance of the face and in the pose, but in the cramped space, the acrid colours, the dryness of handling – far removed from his earlier delight in quality of pigment and sensuality of texture. Producing for the rest of his career mainly figure paintings, including many self-portraits, he presented them not as transcriptions of people and events but as symbols of pure despair, essays in existentialist agony.

Lyonel Feininger and Oscar Kokoschka presented differing but complementary antitheses to Beckmann's pessimistic passion; the one was inventive in style, the other predominantly traditionalist; both were much more joyous in content. Feininger, who rejected groups and never participated in a manifesto, openly declared himself an Expressionist: 'Every work I do serves as an expression of my most personal state of mind at that particular moment, and of the inescapable, imperative need for release by means of an appropriate act of creation, in the rhythm, form, colour and mood of the picture.'

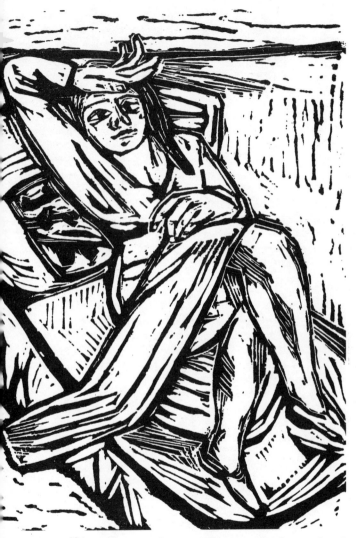

Max Beckmann. *Sleeping Girl*, 1923. Woodcut, $12\frac{5}{8} \times 9\frac{1}{2}$ (32 × 24).

In fact, his inspiration derived mainly from the Cubists, and to a lesser degree from the Futurists; it was the first two qualities, rhythm and form, which were most apparent in his work. Geometric in construction, with metamorphosized figurative elements, his works are sharper than those of Robert Delaunay, with which they have considerable affinities. The colour is brooding, the subject matter larger in scale than the average French Cubist would have attempted; the analysis into geometric units is complete and thorough, taking in every element in the painting – including even the light in the sky. It was light which contributed the major Expressionist element to his works, wrapping them in a sense of mystery and drama, making them, despite the austerity of the style, emotionally disturbing.

More self-confident in its hedonistic cosmopolitanism than Berlin, the capital of the Austro-Hungarian empire had experienced in the closing decades of the nineteenth century a Secession movement dominated by the Byzantine sensuality of Gustav Klimt's paintings. The emotionally liberated principles which underlay the movement were disseminated throughout Europe in the pages of the magazine *Ver sacrum* which greatly influenced Die Brücke.

Stylistically Egon Schiele, one of Klimt's pupils, who was briefly imprisoned for producing what were described as 'pornographic' drawings, depended very much on the luscious linear vitality of Klimt's art, but he added to it a pungent morbidity of his own which is heightened by elegant formal distortions. Even his oil paintings have something of the quality of watercolour, and he found special pleasure in this medium, using it originally for subjects with a marked erotic appeal, but later – especially in those works which he produced in prison – expressing a tormented anguish of spirit.

A good deal is often made of the fact that Kokoschka grew up in the Vienna of Sigmund Freud, and his

50

concern with portraiture – rare in the avant-garde of the twentieth century – is often related to his desire to penetrate beneath the disguise of appearance to the sitter's inner personality. But the effects which critics tend to attribute to psychological penetration are more likely to have been determined by the stylistic attitudes which he formed in the period between 1910 and 1914 when his thin, tortuous linear patterns were reinforced by a passion for rich, heavy impasto through which figures emerge, and by means of which they are defined. In one of his more famous works of this period, *The Bride of the Wind (Die Windsbraut)*, all the qualities which have made his work so popular and so significant are immediately apparent: an immense capacity for visual rhetoric, which can at times descend to pomposity; an ability to contain within a single composition the most disparate elements; and a sense of Baroque vitality. The historical analogy is significant; for throughout his career Kokoschka has basically worked within the framework of traditional Renaissance and post-Renaissance conventions, even favouring the same kind of scale. In *The Bride of the Wind* there are obvious references to El Greco and to Delacroix; the size conforms to that of the *grandes machines* of Rubens or Poussin (it is 181 × 220 cm), and there are no striking innovations in form or construction. What is special to Kokoschka's generation and the Expressionist tradition of art is the apocalyptic treatment of the theme, the morbidity of the colour, and the adaptation of the actual handling of the medium to create a mood and distil a feeling.

It is interesting in this connection to compare Kokoschka's painting with one of the several which his younger contemporary Max Ernst produced on the same theme – significantly, the Germans use the word *Windsbraut* to mean 'Storm Wind' – in the 1920s. Expressionism had been the force which initially liberated Ernst, and his early works before

the war were well within its idiom. But after his encounter with the artistic Nihilism of Dada he turned to various forms of the Surrealist liberation of unconscious imagery.

51 In his *Bride of the Wind* the sense of violence, aggression and disquiet is expressed formally in a style which contains all the basic elements of the Expressionists – emotive colour, turbulent shapes distorted to provoke strong reactions in the spectator – and added to them is a whole series of sexual metaphors, involving the sense of rape, the whole effect heightened by the contrast with the placid lunar circle which occupies the top left-hand segment of the picture.

After the Great War

The political ferment which characterized the post-war years in Germany gave aesthetic allegiances even stronger political undertones than those they had already expressed. Powerful though the appeals of Dada and Futurism were, it was Expressionism which commanded the big aesthetic battalions, and which became identified most clearly with all the progressive elements in the tragedy of the Weimar republic. Even the older painters were inspired by

54 its fervour; and Lovis Corinth, whose vigorous Impressionism had inspired Nolde and Macke, now abandoned this for a charged, violent emotional style – with strong social undercurrents – closer to that of his disciples than to that of his predecessors.

The temper of the times also gave fresh impetus to the interest which the Expressionists had always shown in graphic media – with their propaganda potential being transferred from aesthetic to political ends. The reasons for this interest were many and complex. The stylistic innovations pioneered by Crane and William Morris; the growing popularity of illustrated books; the impact of Beardsley, of

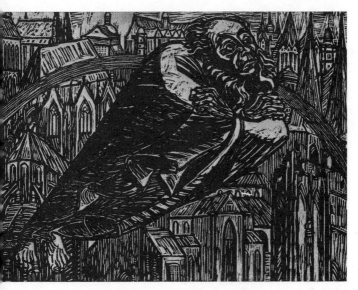

Ernst Barlach. *Manifestations of God: The Cathedrals,*
1922. Woodcut, $10 \times 14\frac{1}{4}$ (25.5 × 36).

Gauguin and of Lucien Pissarro, each of whom in his
own way had extended the range of prints and
engravings, was reinforced by a contemporary
interest in the tradition of the popular German wood-
cut of the late Middle Ages, with its strong demo-
cratic appeal. It was this influence which led artists
such as Nolde, Heckel and Ernst Barlach (1870–1938)
to produce works in black and white, simple in com-
position, urgent in emotional appeal, with perspectival
effects created by the interrelation of planes, and
arrogantly devoid of any attempt to please or charm.
 The desire to rape rather than to seduce the
spectator's sensibilities, which was inherent in many
Expressionist works, seemed especially relevant in
the 1920s; and it was seen at its most compelling in
an artist who, though belonging at one point to the

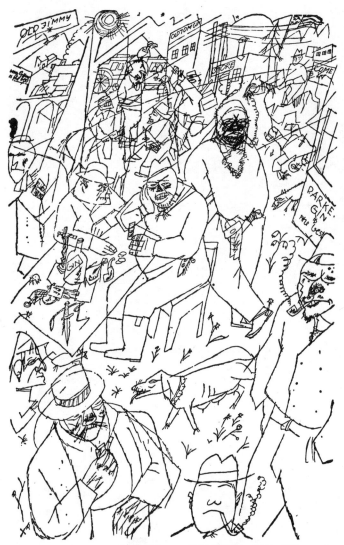

George Grosz. *Gold Diggers*, 1920. Lithograph.

Berlin Dadaists, was at heart committed to the stylistic manners of the Expressionists, using visual violence to excoriate the establishment and propagate his own democratic ideas. George Grosz recorded, with a bitter brilliance which has never been excelled, the unacceptable face of capitalism. He produced a flood of lithographs, prints and paintings which document post-war Germany with the same virulent accuracy with which Daumier portrayed the France of Louis-Philippe. But his strength was his weakness, and though his colour could often be gently lyrical, he could never seem to overcome a basic distaste for humanity, despite the democratic ideals which informed his work. He was always best at his most sadistic, and he exemplifies, in an exaggerated form, the strong streak of Puritanical venom which frequently powers the Expressionist imagination.

The Expressionists had led the last attack on the ramparts of rationality, and had breached them. They gave to instinct a standing in the visual arts which the Romantics had never succeeded in establishing; they declared their independence of the visible world, and gave the subconscious a new significance in the act of creation. The actual techniques which they had evolved were used by many artists to achieve effects not dissimilar from those which they themselves sought. The strong simple colours and passionate vision which characterize the works of a basically Fauve painter such as Matthew Smith (1879–1959) represent one aspect of a tradition which complements the more personal emotional vehemence of an artist such as Jack Yeats, whose concern with a semi-private mythology echoes through thick layers of luminous paint applied with a vigorous, whirling brush stroke. Nor would any member of Die Brücke or Der Blaue Reiter see in the sun-drenched, fiercely expressed imagery of the Australian Arthur Boyd anything very different from what he himself had been trying to achieve.

The passion for violence, the search for ultimates in sensation and feeling which could yet be confined within the traditional framework of painting are yet another aspect of the legacy of Expressionism, and the resemblances between Francis Bacon's *Study of Red Pope* and Chaim Soutine's *Pageboy at Maxim's* are more than fortuitous. Both are motivated by the desire to express in the resonances of colour, in the deformation of lines, in the exaggeration of physical characteristics, a sensational impact experienced by the artist, impressed on the spectator.

At the same time, too, as painters had been moving towards a mode of creativity based on the creative significance of passion, so the aestheticians and the critics were providing new theoretical bases for establishing that infallibility of the *id* which was one of the tacit assumptions of the Expressionist approach. John Russell, for instance, sets out to explain (and in a sense to vindicate) Bacon's multi-planed distorted imagery in terms of the notion of 'unconscious scanning' which Anton Ehrenzweig formulated in *The Hidden Order of Art* (1967), and which is a continuation of an Expressionist theory of creativity first formulated by Worringer fifty years earlier. Rationalization, control, restraint, analysis, are converted into psychological sins; spontaneity, the rejection of conscious vision, 'the chaos of the subconscious', the undifferentiated structure of subliminal perception, are virtues – the true sources of creativity.

The moralistic undertones are obvious, and this was to be emphasized by the fact that when, with the advent of the New York school of Abstract Expressionism, the critic Clement Greenberg set out to provide it with a rationale, he did so virtually in terms of the notion that, because of the absolute spontaneity of works dictated by pure gestural chance, they achieve a kind of liberating truth which is at once virtuous and therapeutic. And this notion

has gone far, spilling over into the conduct of life as 'doing your own thing' and making possible the cult of contemporary culture-heroes such as Joseph Beuys.

Nor are the earlier formal impulses of Expressionism yet exhausted. The *art brut* of a painter such as Jean Dubuffet shows a conscious intention to assault the eye, and he himself has said about the *Corps de Dame* series: 'I have always delighted (and I think this delight is constant in all my paintings) in contrasting in these feminine bodies the extremely general and the extremely particular; the metaphysical and the grotesquely trivial.' Willem de Kooning is one of those who, turning their backs on the earlier purely abstract phases of their careers, have reverted to inspirations which would not have been alien to the early Expressionists.

But to limit the contemporary significance of Expressionism to the occasional survival of its stylistic mannerisms would be to underrate it. More than any other single episode in the history of art during the last century it has emancipated painting, extended the boundaries of form, line and colour, made possible the impossible. Nothing in art that has happened since its beginnings has been untouched by its liberating effect.

Chronology

1888 Brussels: Ensor exhibits *Entry of Christ into Brussels*.
1891 Munich: Kandinsky arrives from Russia.
1892 Berlin: Munch's pictures create scandal at group exhibition.
1897 Vienna: Secession movement founded.
1899 Paris: Matisse meets Derain and others at Académie Carrière.
1902 Berlin: Secession movement founded.
1903 Munich: Important exhibition of French and Belgian Post-Impressionists.
1904 Paris: Matisse holds his first one-man show.
1905 Paris: First Group showing of Fauves .at the Salon d'Automne. Dresden: Die Brücke founded, and holds first group exhibition; first Van Gogh exhibition there.
1906 Paris: Fauves exhibit as a group at Salon des Indépendants.
1907 Paris: Matisse opens an art school. Retrospective exhibition of Cézanne. Berlin: Wilhelm Worringer publishes *Abstraction and Empathy*.
1908 Paris: Fauves begin to break up as a group.
1909 Berlin: Neue Künstlervereinigung founded. Munich: Similar group founded.
1911 Dresden: Last of Die Brücke group leave for Berlin. Munich: Der Blaue Reiter group founded, Almanach published. Berlin: the word 'Expressionist' accepted in catalogue of 21st exhibition of the Berlin Secession.
1912 Berlin: First 'Expressionist' exhibition at Sturm-Galerie. Der Blaue Reiter holds its last exhibition. Munich: End of Neue Künstlervereiningung.
1913 Munich: Virtual dissolution of Der Blaue Reiter.

Further Reading

Inevitably the bibliography of Expressionism is vast, especially when it is enlarged to include monographs on all the artists who have either belonged to the movement or been touched by it. Probably the best short account, valuable not only for its insight but because it covers Expressionism in all the arts, is John Willett's *Expressionism*, London and New York, 1970. Other important general

works are: Wolf-Dieter Dube, *The Expressionists*, London and New York, 1972; Bernard S. Myers, *The German Expressionists*, New York, 1955 (published as *Expressionism*, London 1955); Michel Ragon, *L'Expressionisme*, Lausanne, 1966; Peter Selz, *German Expressionist Painting*, Berkeley, 1957.

More specialized aspects are dealt with in the following: Lothar Günther Buchheim, *The Graphic Art of German Expressionism*, New York, 1960; Carl Zigrosser, *The Expressionists: A Survey of their Graphic Art*, New York, 1957; L.D. Ettlinger, 'German Expressionism and Primitive Art', *Burlington Magazine* (London), April 1968; D.E. Gordon, 'On the Origin of the Word "Expressionism"', *Journal of the Warburg and Courtauld Institutes* (London), xxix, 1966; Charles Kessler, 'Sun-worship and Anxiety; Nature-nakedness and Nihilism in German Expressionist Painting', *Magazine of Art* (Paris and New York), November 1952; Emile Langui, *Expressionism in Belgium*, Brussels, 1971; Denis Sharp, *Modern Architecture and Expressionism*, London, n.d.; Lothar Lang, *Expressionist Book Illustration in Germany*, London and Boston, 1976.

The most penetrating examination of the relationship between Fauves and Expressionists is in the catalogue of the exhibition 'Le Fauvisme français et les débuts de l'Expressionisme allemand', Musée National d'Art Moderne, Paris, 1966. There is an exhaustive bibliography of Fauvism in what is still one of the most valuable books on the movement, Georges Duthuit's *The Fauvist Painters*, New York, 1950, which first appeared as a series of articles in *Cahiers d'art*. Other important studies of the movement are: Umbro Apollonio, *Fauves and Cubists*, London, 1959; Jean-Paul Crespelle, *The Fauves*, London, 1963; Jean Leymarie, *Fauvism, a Biographical and Critical Study*, London and New York, 1959; John Rewald, introduction to the catalogue 'Les Fauves', Museum of Modern Art, New York, 1952; John Elderfield, catalogue 'The "Wild Beasts": Fauvism and its Affinities', Museum of Modern Art, New York, 1976.

List of Illustrations

Measurements are given in inches and centimetres, height first.

14 Georges Rouault (1871–1958). *Versailles: the Fountain*, 1905. Watercolour and pastel, $26\frac{1}{2} \times 21$ (67.5 × 53.5). Private collection. See p. 15.

15 Georges Rouault (1871–1958). *Bal Tabarin (Dancing the Chahut)*, 1905. Watercolour and pastel, $27\frac{3}{4} \times 21\frac{1}{4}$ (70.5 × 54). Ex-collection Girardin; Musée d'Art Moderne de la Ville de Paris. See p. 14.

16 Raoul Dufy (1877–1953). *Placards at Trouville*, 1906. Oil on canvas, $34\frac{5}{8} \times 25\frac{5}{8}$ (88 × 65). Musée National d'Art Moderne, Paris. See p. 13.

17 Othon Friesz (1879–1949). *Sunday at Honfleur*, 1907. Oil on canvas. Musée Toulouse-Lautrec, Albi. See p. 13.

18 André Derain (1880–1954). *Banks of the Seine at Pecq*, 1905. Oil on canvas, $37\frac{3}{8} \times 33\frac{1}{2}$ (95 × 85). Musée National d'Art Moderne, Paris. See p. 12.

19 Edvard Munch (1863–1944). *Death and the Maiden*, 1893. Oil on canvas, $50\frac{3}{8} \times 33\frac{7}{8}$ (128 × 86). Oslo, Municipal Museum (Munch Museum). See p. 17.

20 Edvard Munch (1863–1944) *Madonna*, 1895/1902. Lithograph, $35\frac{7}{8} \times 17\frac{1}{2}$ (60.7 × 44.3). See p. 16.

21 James Ensor (1860–1949). *The Singular Masks*, 1891. Oil on canvas, 41×33 (100 × 80). Musées Royaux des Beaux-Arts de Belgique, Brussels. See p. 20.

22 James Ensor (1860–1949). *Skeletons Warming Themselves at a Stove (or: No Fire, Will You get some tomorrow?)*, 1889. Oil on canvas, $25\frac{1}{4} \times 18$ (64 × 46). Private collection. See p. 23.

23 James Ensor (1860–1949). *The Entry of Christ into Brussels*, 1889. Oil on canvas, $98\frac{3}{8} \times 170\frac{7}{8}$ (250 × 434). Musée Royal des Beaux-Arts, Antwerp. See p. 21.

24 Rik Wouters (1882–1916). *Nel Wouters*, 1912. Oil on canvas, $50\frac{3}{8} \times 42$ (128 × 107). Musées Royaux des Beaux-Arts de Belgique, Brussels. See p. 24.

25 Gust de Smet (1877–1943). *The Striped Skirt*, 1941. Oil on canvas, $27\frac{5}{8} \times 22$ (70 × 56). Private collection, Ghent. See p. 25.

26 Léon Spilliaert (1881–1946). *Tall Trees*, 1921. Watercolour on paper, $29\frac{7}{8} \times 21\frac{5}{8}$ (76 × 55). Private collection, Brussels. See p. 26.

27 Vincent van Gogh (1853–90). *Dr Gachet's Garden*, Auvers, May 1890. Oil on canvas, $28\frac{3}{4} \times 20\frac{1}{4}$ (73 × 51.5). Musée du Louvre, Paris. See p. 9.

28 Constant Permeke (1886–1952). *Golden Landscape*. Oil on canvas, $39\frac{3}{8} \times 51\frac{1}{8}$ (100 × 130). Collection Fondation Jules D'Hondt-Dhaenens, Deurie. See p. 25.

29 Ernst Ludwig Kirchner (1880–1938). *Figures on Stones (Fehmarn)*, 1912–13. Watercolour and charcoal, $18\frac{1}{2} \times 23\frac{1}{2}$ (46 × 59). Copyright by Roman Norbert Ketterer, Campione d'Italia. See p. 29.

30 Karl Schmidt-Rottluff (1884–). *Lady with Fruit-dish*, 1909. Private collection. See p. 33.

31 Ernst Ludwig Kirchner (1880–1938). *Five Women in the Street*, 1913. Oil on canvas, $47\frac{1}{4} \times 35\frac{1}{2}$ (120 × 90). Wallraf-Richartz Museum, Cologne. Copyright by Roman Norbert Ketterer, Campione d'Italia. See p. 30.

32 Otto Mueller (1874–1930). *Two Girls in the Grass*. Tempera, $55\frac{1}{2} \times 43\frac{3}{8}$ (141 × 110). Staatsgalerie moderner Kunst, Munich. Loan from L. G. Buchheim collection. See p. 39.

33 Egon Schiele (1890–1918). *For My Art and for My Loved Ones I Will Gladly Endure to the End!*, 25 April 1912. Pencil and watercolour. Albertina Museum, Vienna. See p. 50.

34 Egon Schiele (1890–1918). *Portrait of the Painter Paris von Gütersloh*, 1918. Oil on canvas, $43 \times 55\frac{1}{4}$ (109.9 × 140.3). Institute of Arts, Minneapolis. Gift of the P. D. McMillan Land Company. See p. 50.

35 Ernst Ludwig Kirchner (1880–1938). *Semi-nude Woman with Hat*, 1911. Oil on canvas, $29\frac{7}{8} \times 27\frac{1}{2}$ (76 × 70). Wallraf-Richartz Museum, Cologne. Copyright by Roman Norbert Ketterer, Campione d'Italia. See p. 30.

36 Alexei von Jawlensky (1864–1941). *Girl with Peonies*, 1909. Oil on cardboard, $39\frac{3}{4} \times 29\frac{1}{2}$ (101 × 75). Von der Heydt Museum, Wuppertal. See p. 44.

37 Max Beckmann (1884–1950). *Self-portrait with a Red Scarf*, 1917. Oil on canvas, $31\frac{1}{2} \times 23\frac{5}{8}$ (80 × 60). Staatsgalerie, Stuttgart. See p. 48.

38 George Grosz (1893–1959). *Market Scene with Fruits*, 1934. Watercolour on paper, 25×18 (63.4 × 45.7). Private collection. See p. 55.

39 Wilhelm Liszt. *Ver Sacrum Kalender*, 1903. See p. 50.

40 August Macke (1887–1914). *Lady in a Green Jacket*, 1913. Oil on canvas, $17\frac{1}{2} \times 17\frac{1}{8}$ (44.5 × 43.5). Wallraf-Richartz Museum, Cologne. See p. 44.

41 Karl Schmidt-Rottluff (1884–). *Summer*, 1913. Oil on canvas, $34\frac{5}{8} \times 41$ (88 × 104). Niedersächsisches Landesmuseum, Hanover. See p. 33.

42 Max Pechstein (1881–1955). *Nude in a Tent*, 1911. Oil on canvas, $31\frac{5}{8} \times 27\frac{3}{4}$ (80.5 × 70.5). Staatsgalerie moderner Kunst, Munich. See p. 38.

43 Lyonel Feininger (1871–1956). *Zirchow V*, 1916. Oil on canvas, $31\frac{1}{2} \times 39\frac{3}{8}$ (80 × 100). The Brooklyn Museum, New York. See p. 50.

44 Paul Klee (1879–1940). *The Föhn Wind in the Marcs' Garden*, 1915. Watercolour, $7\frac{7}{8} \times 5\frac{7}{8}$ (20 × 15). Städtische Galerie im Lenbachhaus, Munich. See p. 45.

45 Franz Marc (1880–1916). *Deer in Wood II*, 1913–14. Oil, $51 \times 39\frac{3}{8}$ (129.5 × 100). Staatliche Kunsthalle, Karlsruhe. See p. 44.

46 Franz Marc (1880–1916). *Tiger*, 1912. Oil on canvas, $43\frac{1}{4} \times 39\frac{3}{4}$ (110 × 101). Städtische Galerie im Lenbachhaus, Munich. See p. 44.

47 Wassily Kandinsky (1866–1944). *On the Outskirts of the City*, 1908. Oil on cardboard, $19\frac{1}{4} \times 27$ (49 × 68.8). Städtische Galerie im Lenbachhaus, Munich. See p. 42.

48 Wassily Kandinsky (1866–1944). *Large Study*, 1914. Oil, $39\frac{3}{8} \times 30\frac{3}{4}$ (100 × 78). The Solomon R. Guggenheim Museum, New York. See p. 43.

49 Erich Heckel (1883–1970). *Nude on a sofa*, 1909. Oil on canvas, $37\frac{3}{4} \times 47\frac{1}{4}$ (96 × 120). Staatsgalerie moderner Kunst, Munich. See p. 32.

50 Erich Heckel (1883–1970). *Brickworks*, 1907. Oil on canvas, $26\frac{3}{4} \times 33\frac{5}{8}$ (68 × 86). Collection Roman Norbert Ketterer, Campione d'Italia. See p. 31.

51 Max Ernst (1891–1976). *The Bride of the Wind*, 1926–27. Oil on canvas, $32\frac{1}{8} \times 39\frac{1}{2}$ (81.5 × 100.5). Staatliche Kunsthalle, Karlsruhe. See p. 52.

52 Oskar Kokoschka (1886–). *The Bride of the Wind (The Tempest)*, 1914. Oil on canvas, $71\frac{1}{4} \times 86\frac{5}{8}$ (181×220). Kunstmuseum, Basle. See p. 51.

53 Alfred Kubin (1877–1959). *One-eyed Monster*. Oil on canvas. See p. 46.

54 Lovis Corinth (1858–1925). *The Painter Bernd Grönvold*, 1923. Kunsthalle, Bremen. See p. 52.

55 Emil Nolde (1867–1956). *Tropical Sun*, 1914. Oil on canvas, $27\frac{1}{2} \times 41\frac{3}{4}$ (70×106). Ada and Emil Nolde Foundation, Seebüll. See p. 36.

56 Emil Nolde (1867–1956). *The Dance Round the Golden Calf*, 1910. Oil on canvas, $34\frac{5}{8} \times 41\frac{3}{8}$ (88×105). Staatsgalerie moderner Kunst, Munich. See p. 35.

57 Chaim Soutine (1894–1943). *Pageboy at Maxim's (Le Chasseur d'Hôtel)*, 1927. Oil on canvas, $60\frac{3}{8} \times 26$ (153.4×66). Albright-Knox Art Gallery, Buffalo, N.Y. Edmund Hayes Fund. See p. 56.

58 Francis Bacon (1909–). *Study of Red Pope (Study from Innocent X)*, 1962. Oil on canvas, 78×56 (196×142). Private collection. See p. 56.

59 Jean Dubuffet (1901–). *Corps de Dame*, 1950. Watercolour, $12\frac{1}{4} \times 9\frac{1}{4}$ (31×23.5). Private collection, London. See p. 57.

60 Willem de Kooning (1904–). *Woman and Bicycle*, 1952–3. Oil on canvas, $76\frac{1}{2} \times 49$ (94.5×24.5). Collection Whitney Museum of American Art, New York. See p. 57.

61 Jack B. Yeats (1871–1957). *Many Ferries*, 1948. Oil on canvas, $20\frac{1}{8} \times 27\frac{1}{8}$ (51×69). Courtesy of the National Gallery of Ireland, Dublin. By permission of Anne and Michael Yeats. See p. 55.

62 Arthur Boyd (1920–). *White Nebuchadnezzar Running Through Forest with Lion Roaring*, 1968–71. Oil on canvas, 43×45 (109.6×114.7). Private collection. See p. 55.

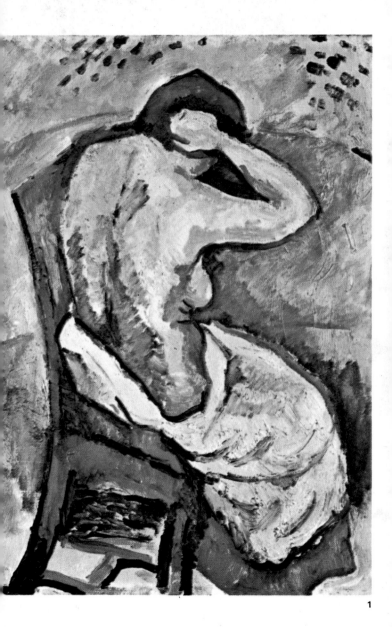

1

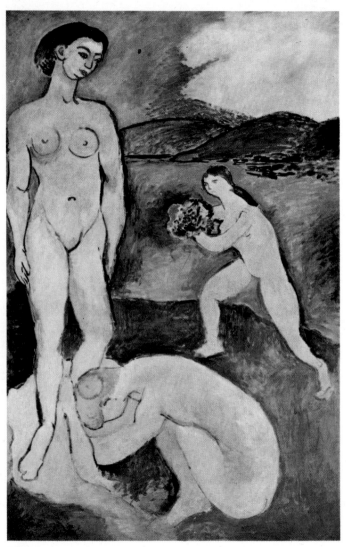

2

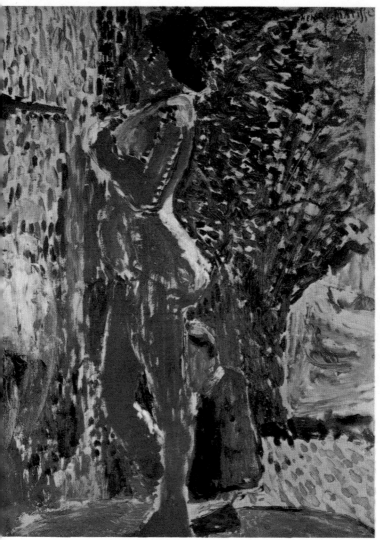

3

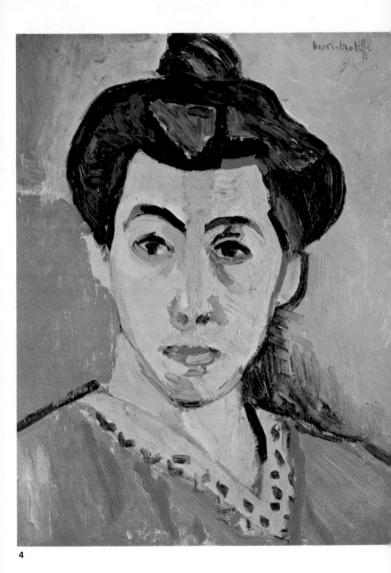

4

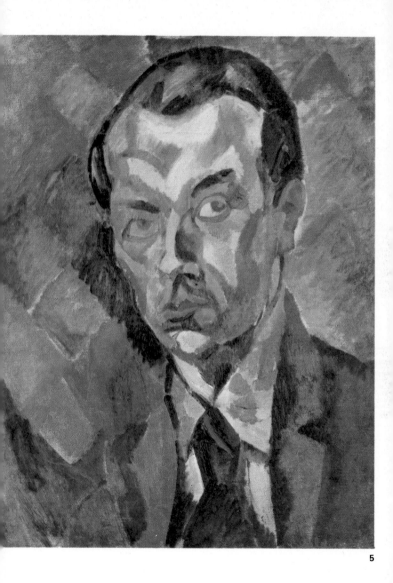

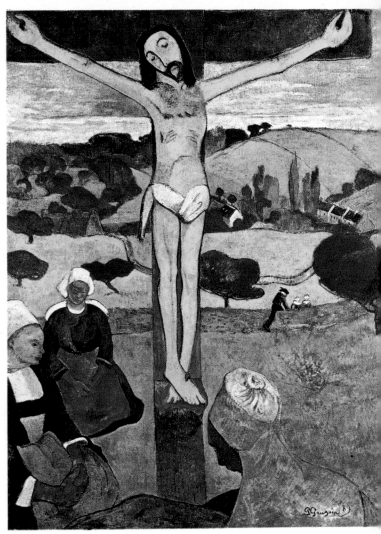

6

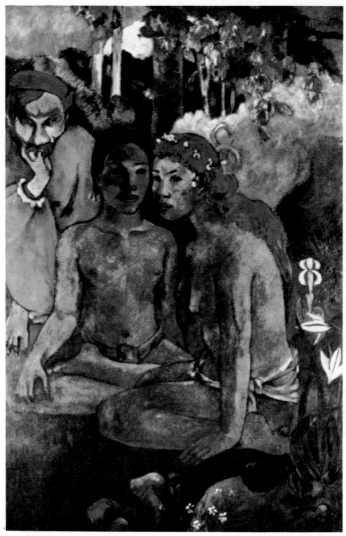

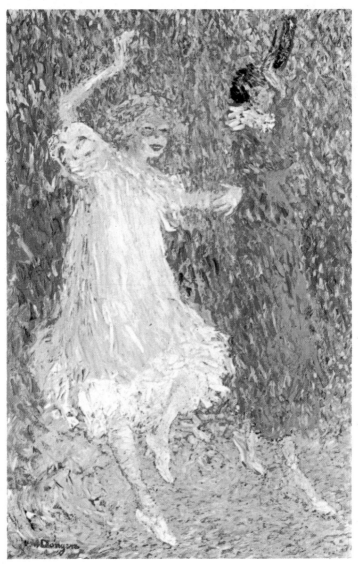

8

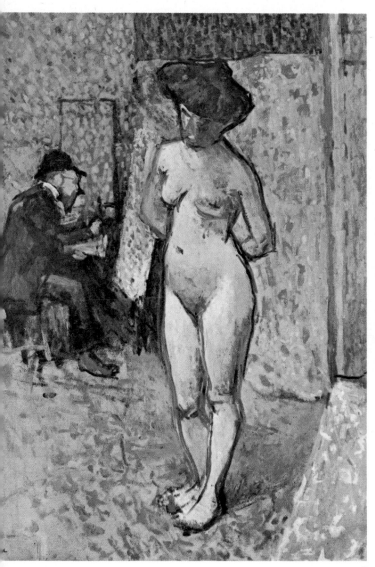

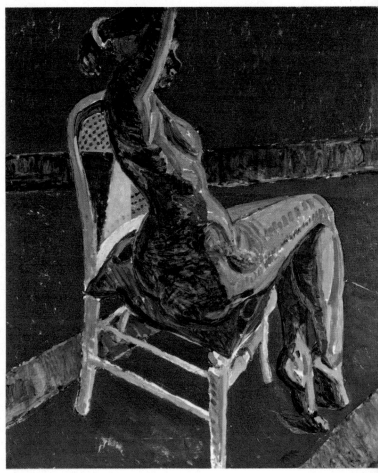

10

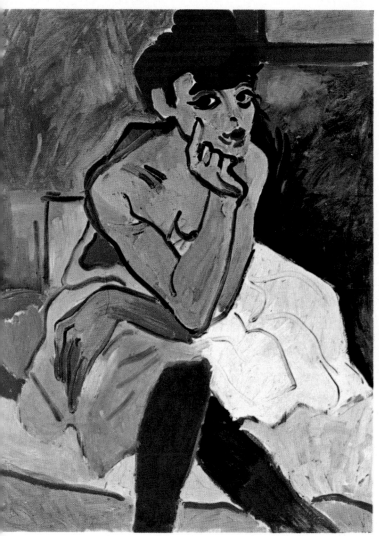

11

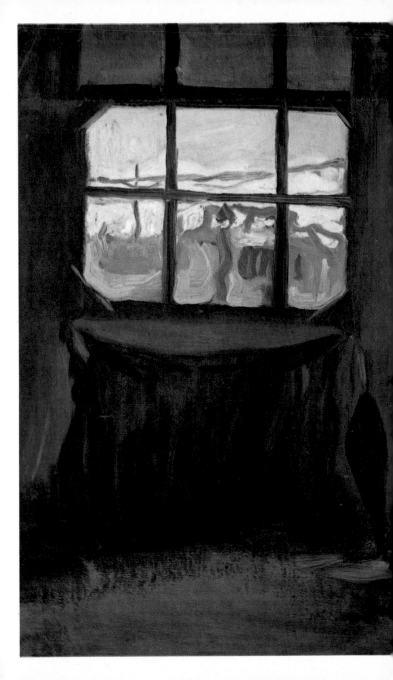

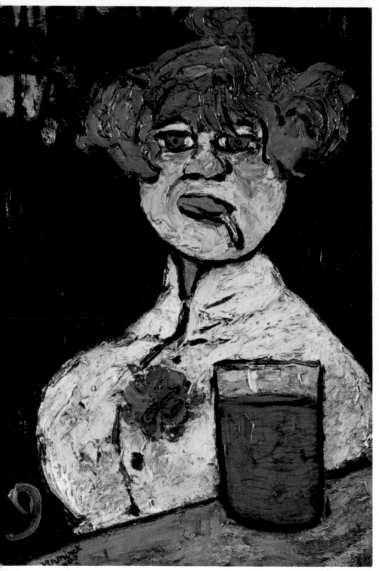

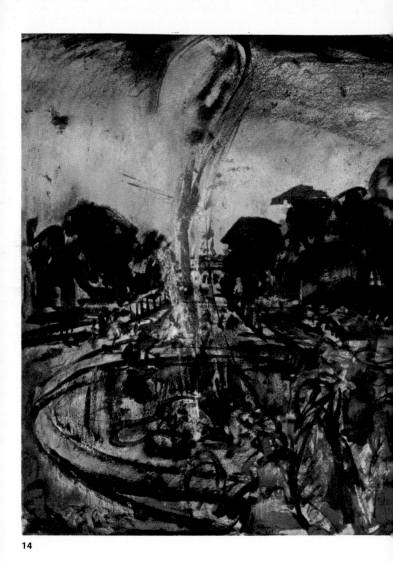

14

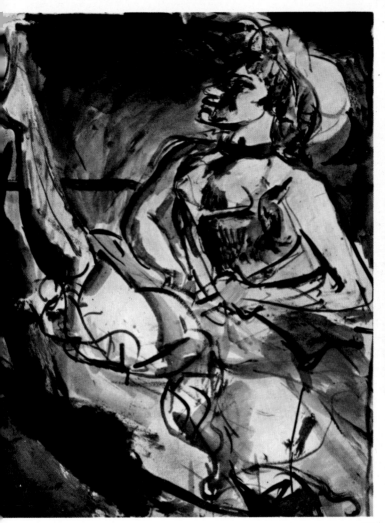

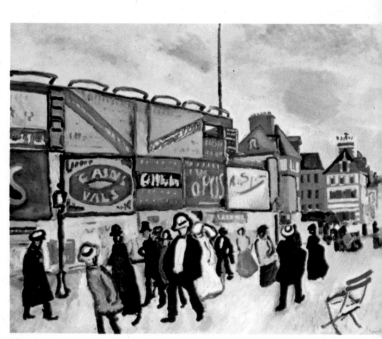

16

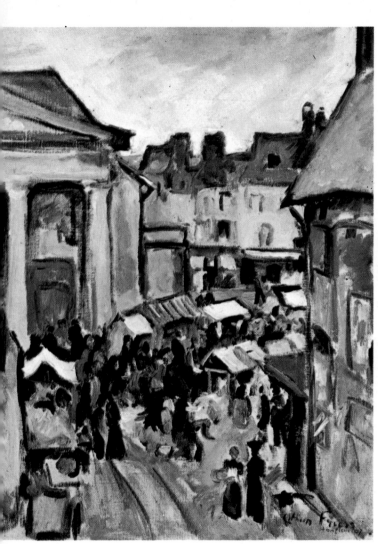

17

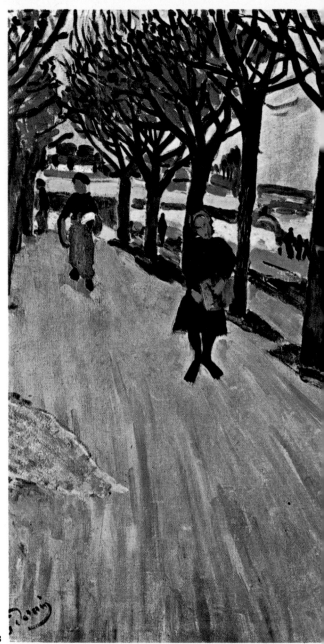

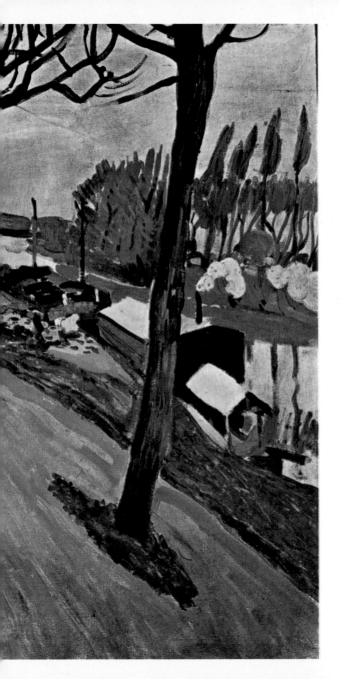

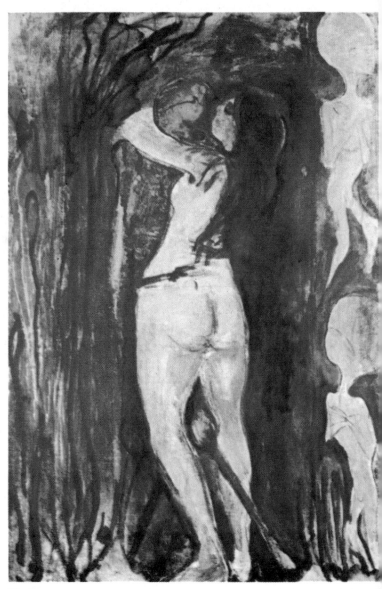

19

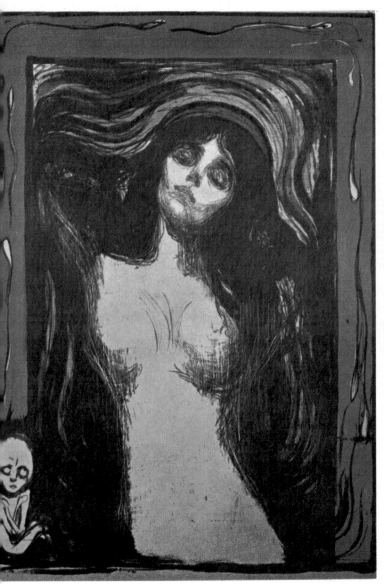

21

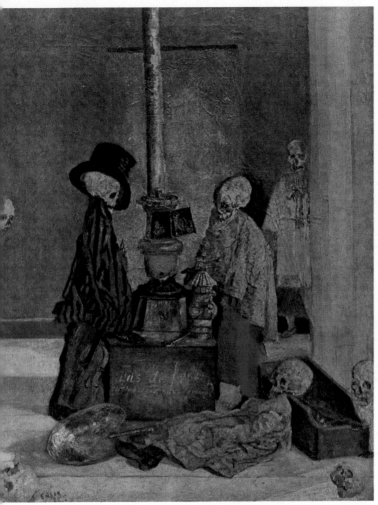

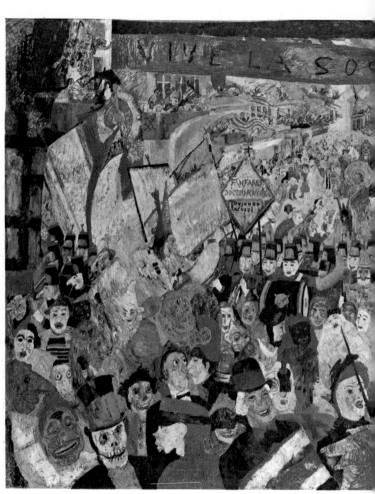

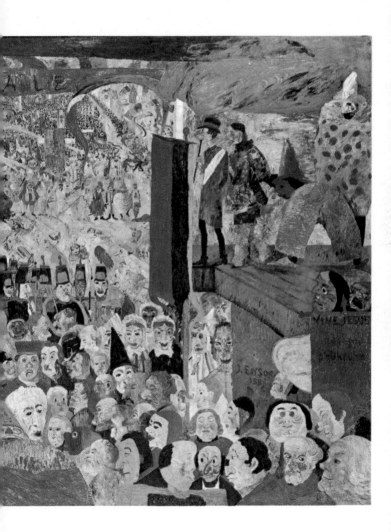

Gust. De Smet

26

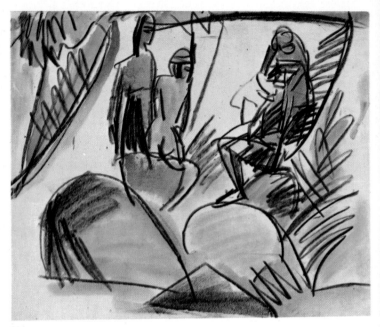

29

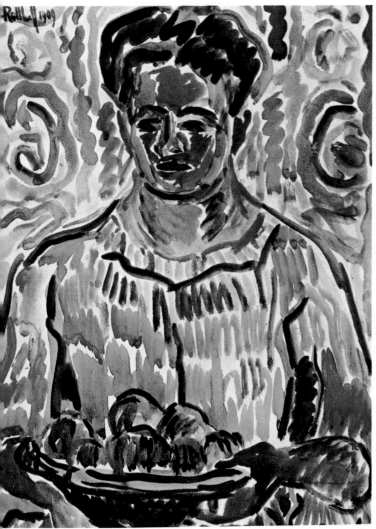

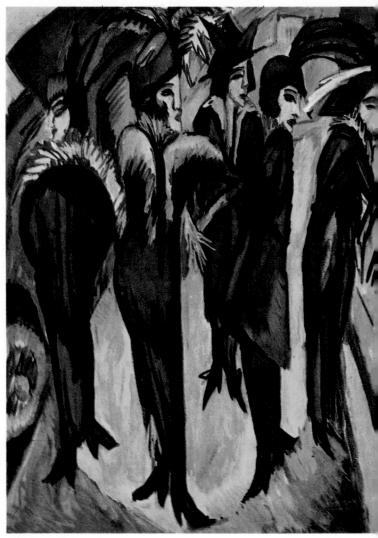

31

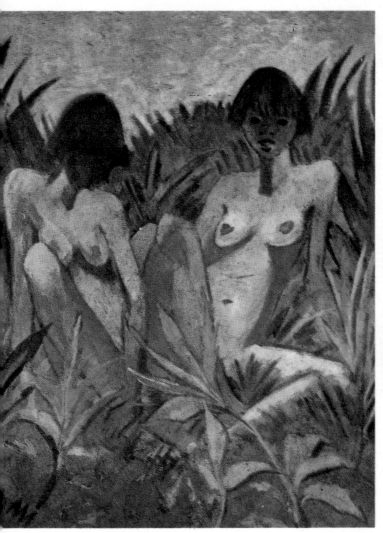

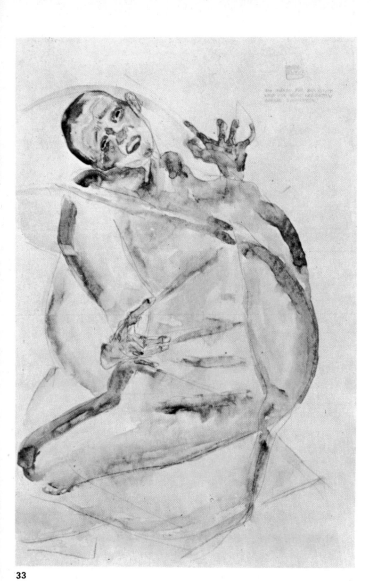

33

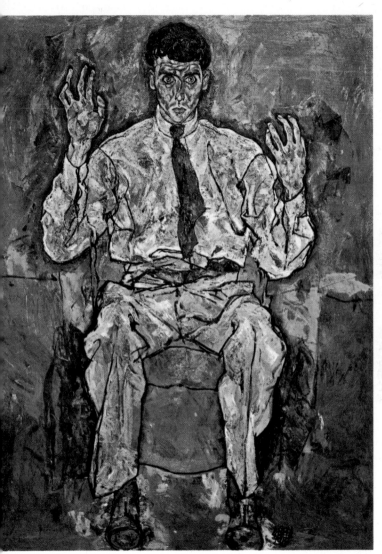

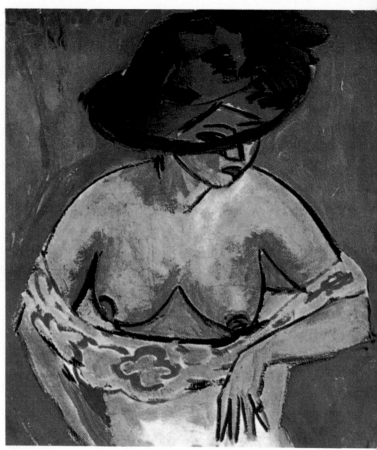

35

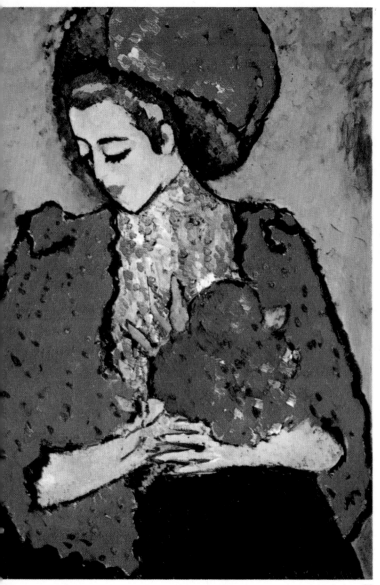

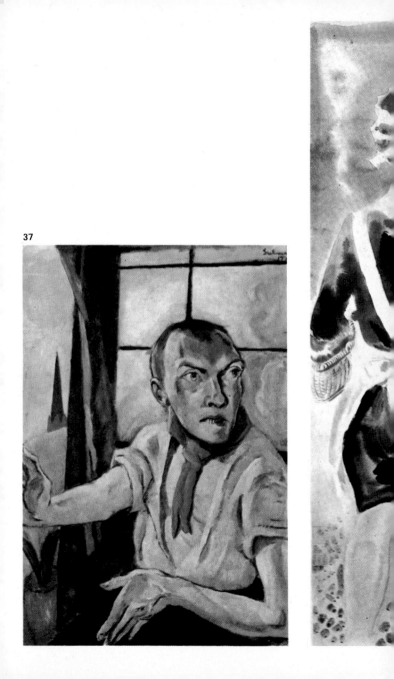

37

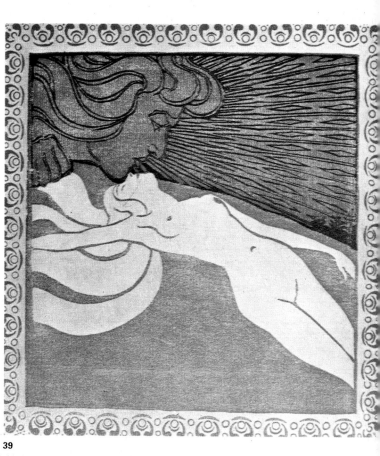

39

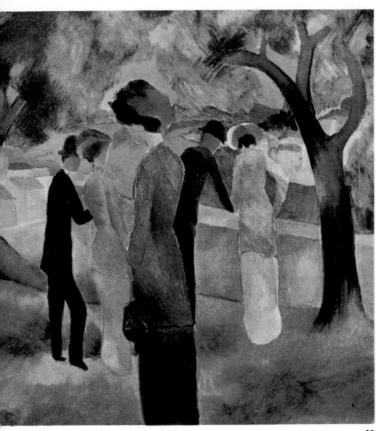

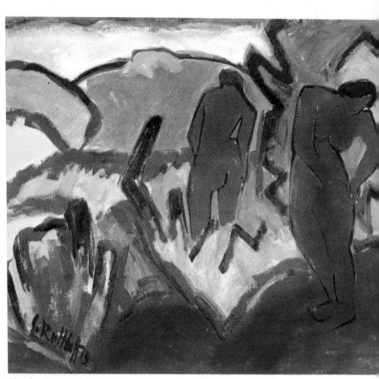

41

42

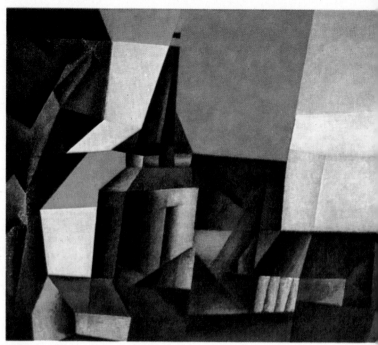

43

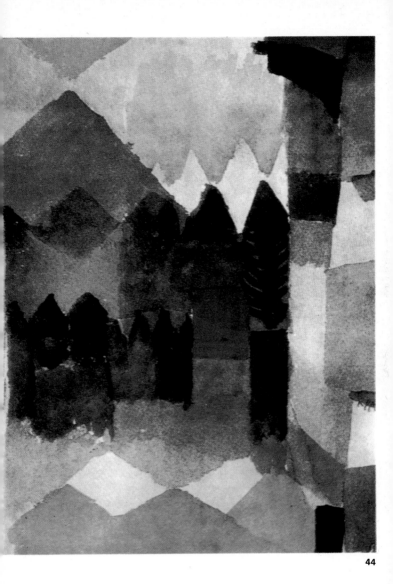

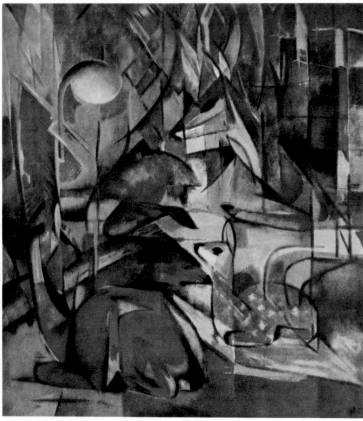

45

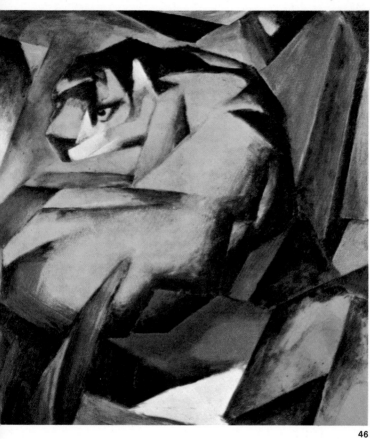

46

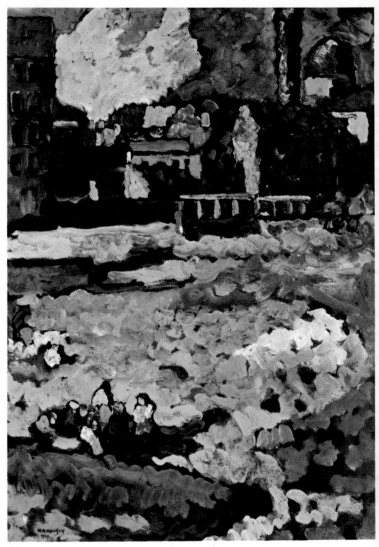

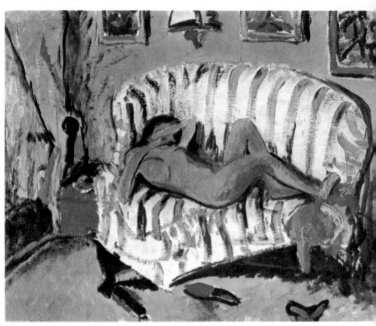

49

50

51

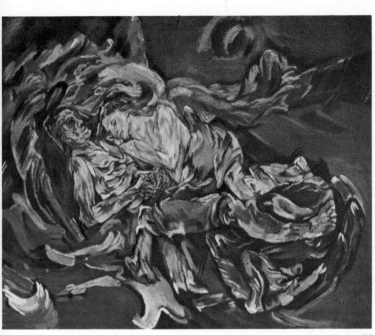

52

53

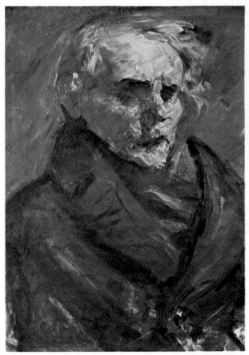

54

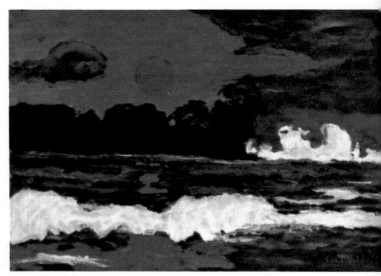

55

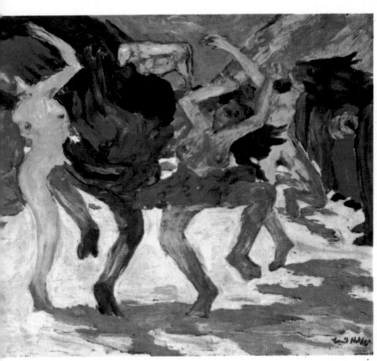

56

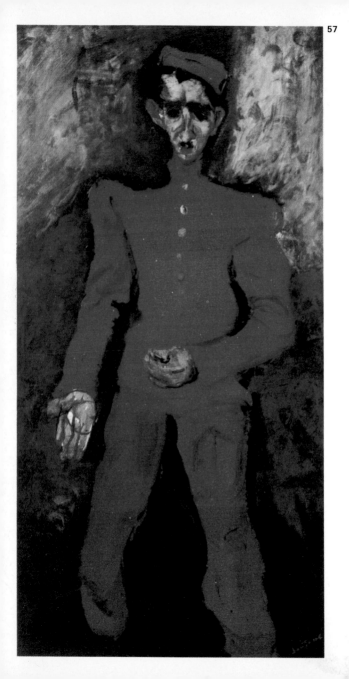

58 ▶

61

62